The
MOORLANDS
of
ENGLAND

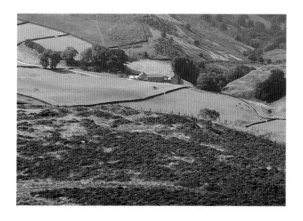

THE
MOORLANDS
OF
ENGLAND

Photography by DUDLEY WITNEY
Text by ADAM HOPKINS

KEY PORTER BOOKS

To Sir Neil and Lady Shaw — Neil and Pixie —
whose friendship and generosity made this venture possible.

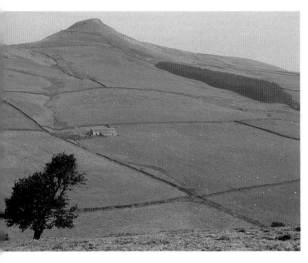

PAGE 1:
A valley farmstead in the Peak District.

PAGES 2 AND 3:
Beech trees planted on Exmoor by nineteenth-century "improvers".

PAGE 4:
Sheep and stone walls occupy the hillsides near Wildboarclough in the Peak District.

PAGE 5:
Stone walls near Mytholmroyd, West Yorkshire.

Canadian Cataloguing in Publication Data
Witney, Dudley
 The moorlands of England

ISBN 1-55013-605-4

1. Moors and heaths — England — Pictorial works.
2. Moors and heaths — England — Guidebooks.
3. England — Pictorial works.
4. England — Guidebooks.
I. Hopkins, Adam, 1939– . II. Title.

DA632.W57 1995 914.204'859 C94-932725-5

The publisher gratefully acknowledges the assistance of the Canada Council, the Ontario Arts Council and the Ontario Publishing Centre.

Key Porter Books Limited
70 The Esplanade
Toronto, Ontario
Canada M5E 1R2

Distributed in the UK by
Verulam Publishing Ltd.
152a Park Street Lane
Park Street, St. Albans
Hertfordshire AL2 2AU

Design: Scott Richardson
Maps: VISU*TronX*
Electronic assembly: Jean Lightfoot Peters
Printed and bound in Hong Kong

95 96 97 98 99 6 5 4 3 2 1

C O N T E N T S

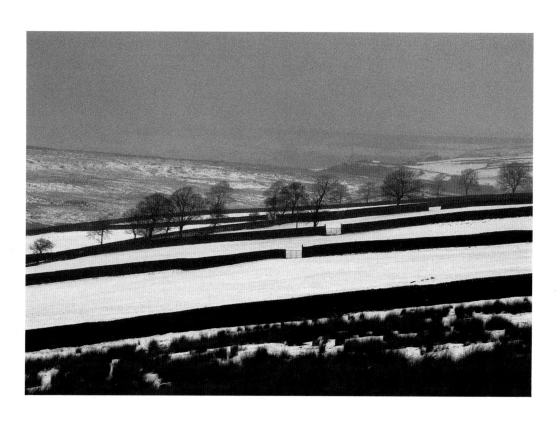

CHAPTER ONE
THE NATURE OF THE MOORS 6

CHAPTER TWO
FIRSTCOMERS 26

CHAPTER THREE
THE MOORS IN HISTORY 44

CHAPTER FOUR
THE MOORS OF IMAGINATION 88

CHAPTER FIVE
THE LIVING MOORS 110

Gazetteer 134

Acknowledgements 141

Index 142

THE NATURE OF THE MOORS

BEYOND ALL ELSE THE MOORS OF ENGLAND — NOT ALL OF THEM BUT MOST — GIVE OFF A SENSE of the primordial, a ruggedness we recognise as if the moors themselves were a dreamscape of our own, the wild part of our natures. Where did they come from, we find ourselves asking? What do they mean? And later, inevitably, we start to ask whether they will be able to survive into the future.

As for their looks, the English moors present a landscape that is unmistakable, composed of height and bulk, of black peatbog, of brilliant, multiple-starred sphagnum moss, of greeny-yellow grasses and ankle-grabbing heather. The moors offer wild sweeps and fells, with rocky crags and edges, humps and horizons receding into what appears, most curiously for a small island, a kind of infinity. The heather swings right through the colour chart, from browny-black in winter to a wistful purple by mid-August, lasting on into the first weeks of September. During these weeks, the purple stretches out across the hills, humming and pulsing with bees, smelling literally as sweet as honey. As night falls, tiny, wispy moths replace the bees, fluttering out among the millions upon millions of diminutive heather blooms. This is a time of deep peace on the moors, of soft and languorous content, shared with the sheep, which are, when humans have departed, the principal inhabitants of the moors.

But if instead of summer days and heather in full bloom, you can imagine an early evening in December, no road within ten miles or so, dark falling fast and temperature dropping, rain coming down somewhere between vicious and simply drenching, grouse invisible and silent, sheep water-logged, the ground not heathery but peaty and riven with wet black holes and small ravines, each wide hillside appearing drearier and more featureless than the last, and home seemingly more distant with every step you slog towards the journey's end — then you will begin to know a little of the other side of the moors. For some people this more

OPPOSITE PAGE:
A view near Luccombe. The soft contours of inland Exmoor seem to soothe the eye, rather than challenge it.

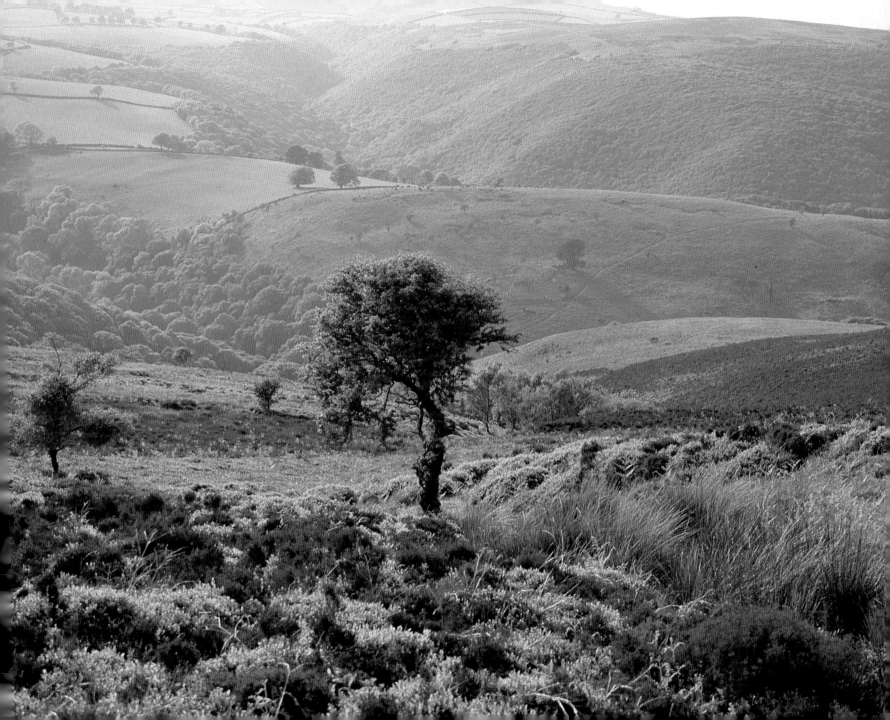

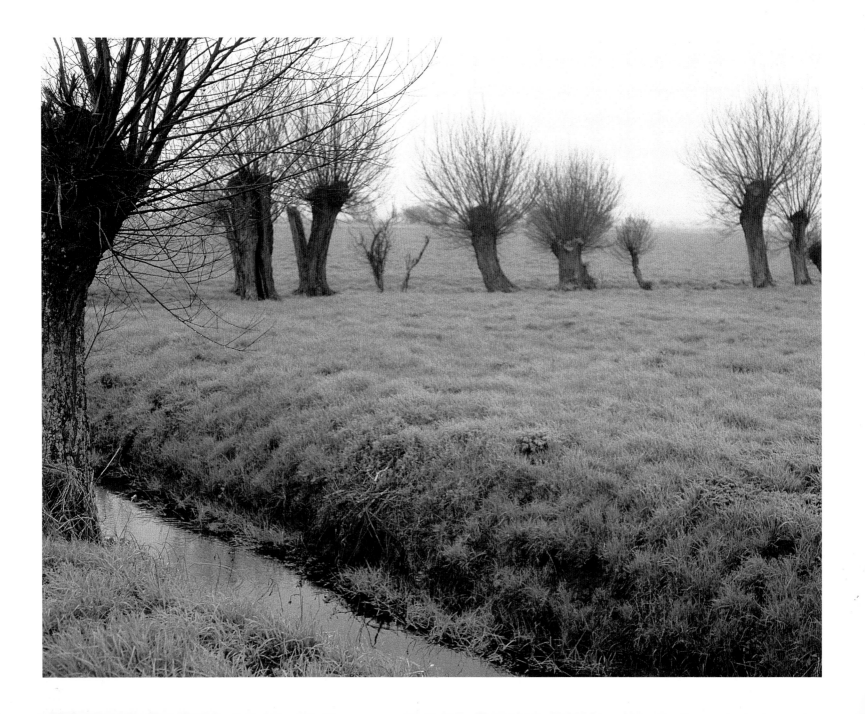

forbidding aspect — the endless challenge, the cussedness, the sense, occasionally, of overwhelming loss and grief — best expresses the spirit of these tracts of wild and lofty countryside.

All of the higher moors have this in common — that you can walk and walk and walk across them, in winter as in summer, submitting yourself to all their rapidly changing moods and circumstances, to a sense of endlessness and sometimes of sublimity.

These are the upland moors. But take one look at the detailed Ordnance Survey maps of lowland Britain, especially across the southern half, and you will notice that all kinds of places with nothing obvious to do with hills or heather, sheep or grouse, are also designated as moor. They include, for example, Sawston Moor near Cambridge and a chunk of land near Oxford known as Otmoor. In some flat areas, like the Somerset Levels, down towards England's south-west corner, the moors individually identified on the map rub up so close together that you realise this whole part of the country, in principle, is classified as moor.

Yet nowhere could be more different from the upland moors. The Somerset Levels comprise one of the most tranquil landscapes in all England — soft, green pastureland with watery dikes and ditches, with swans and a host of lesser waterbirds, molehills by the thousand and pollarded willows stubby under the wide skies of a flat country. About the only thing in common with the uplands is the presence of peat.

The ditches and dikes reveal that, like the bulk of Holland and most of the East Anglian Fens, the Levels were once far more watery than they are now — indeed, their present drying-out and the drop in the water table has been a most bitterly contested environmental issue. But it was the watery nature of the Levels that qualified this English lowland for the name of moor.

There were, in fact, two radically different meanings for the single word. "Mōr" was the word used by the Anglo-Saxons when translating Latin "mons", more familiar nowadays as "mountain". But "mons" often meant rather more than mountain, coming closer to modern Spanish "sierra" — embracing everything, that is, from outright mountain-range to wild

OPPOSITE PAGE:
In the Somerset Levels, a dike runs through a field punctuated with pollarded willows.

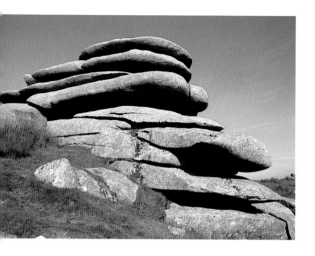

ABOVE:
A rock formation on Cheesewring Hill, Bodmin Moor. The name "cheesewring" refers to the old cheesemaker's press, which was used to squeeze out water from cheese.

hill-country. What matters in this definition is that it was not cultivated. Whence, very satisfactorily, the upland English moor. The other kind of moor, embodied in so many place names and coming once again from Anglo-Saxon "mōr", meant simply wet and waste.

So we have two kinds of moor, lowland and upland, utterly unconnected. The Somerset Levels are particularly fascinating and must stand in here for all their lowland fellows, most now drained and turned into undistinguished field or indistinguishable cityscape. But to understand the upland moors, there is no better approach than to look at them one by one. Only then can we begin to grasp how deeply different they are from each other under their surface similarities. The rocks beneath give them their physical character, just like the skull beneath the human skin.

FOR A JOURNEY THAT WILL LEAD FROM ENGLAND'S SOUTH-WESTERN PENINSULA SOME HUNDREDS of miles to the Scottish border, there is no better place to start than at Land's End itself, the most distant point of Cornwall. Land's End, uncompromisingly, is made of granite, and much of its upper surface is rough moorland. Granite likewise forms the base of Bodmin Moor, nearest to Land's End of the full-blown moors of the West Country. Here the harsh, hard rock gives the hills their underlying form and then breaks through, especially on peaks, to form those distinctive clumps we know as "tors" — cracked and split along their faultlines by the elements and often hiding on their upper surfaces curious declivities and basins. Some of the tors are like rough castle crags; others like stacked bread loaves or old-fashioned cheese presses. Beneath them on the slopes lies loose rock, known as clitter, pared away from the tors by wind and frost and rain. It is a wild, impressive, lonely landscape, rising and falling, swelling and diminishing, a place of cotton grass and gorse as well as heather.

If the tors and clitter of Bodmin give it, on a winter's day, a rugged, unforgiving look, the same is far more true of Dartmoor, where the hills are bigger and wilder, the valley sweeps more extensive, the tors more fantastical in shape and far more numerous, and even the clitter grander. There is extensive peatbog, 12 to 15 feet deep in places and genuinely dangerous.

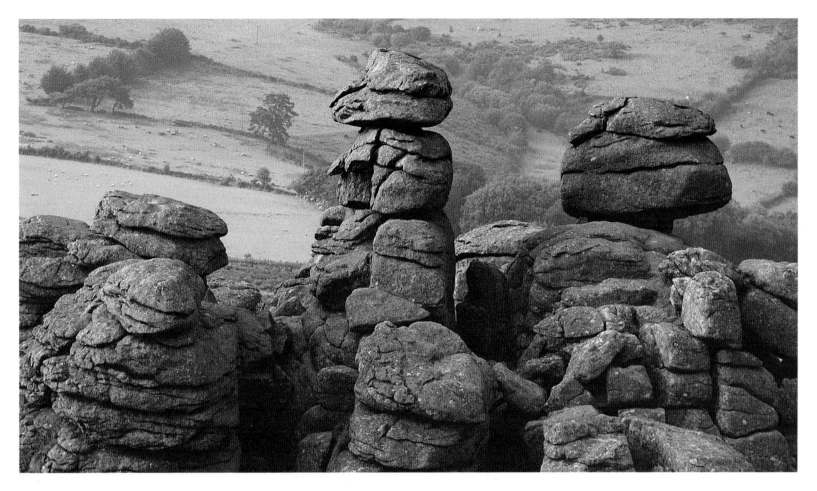

ABOVE:
The rocks of Hound Tor are among the most impressive — and pleasing — on Dartmoor.

This certainly gives the moor a part of its sombre character, but Dartmoor above all means rock — rock dark and menacing and utterly unsubdued. That rock of course is granite. Part of the fascination of the West Country is that Land's End, Bodmin and Dartmoor are all hewn from the same mighty chunk of granite. Lying about them, as rocky as the tors, are the ruinous abodes and monuments of prehistoric man, almost brand new compared to the rocks beneath but conveying to the visitor a sense of awesome ancientness.

"As old as the hills", says the catch-phrase, but to get a feel for the origins of the

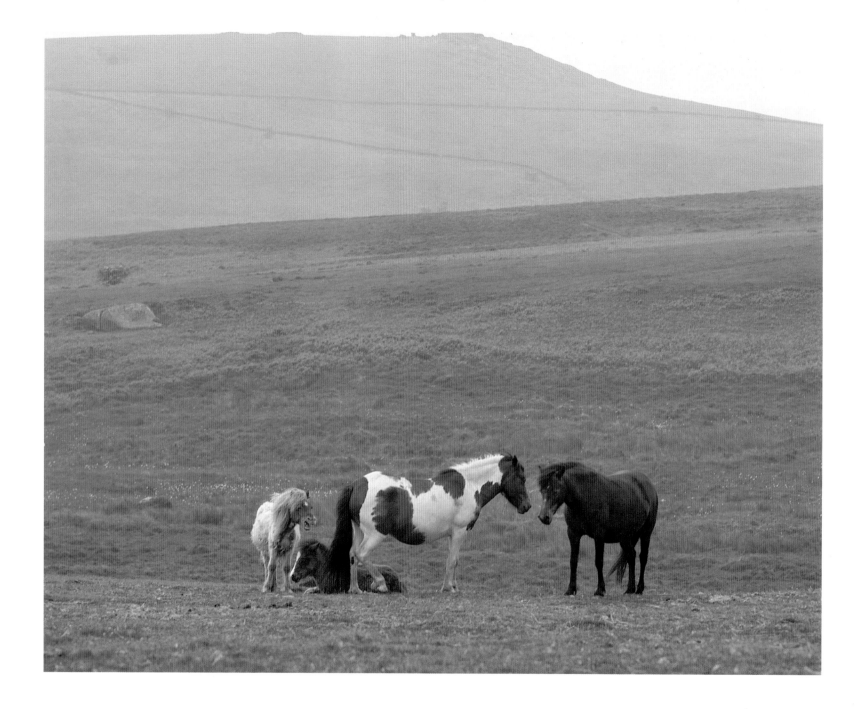

English moors it is necessary to go back into what has been well called "deep time". Continents emerged and reassembled themselves in different landmasses. Oceans came and went. The rocks that lie today beneath the English moorlands — visible to our eyes where they outcrop or have been opened up by quarrying — have lain beneath tropical seas, had fresh rocks laid on top of them by sedimentary action, then had them scraped away, have been upthrust and folded, riven with faults when rocky masses slipped from position alongside one another or have themselves been pushed up through overlying masses.

Experts agree that the granite of the West Country was thrust up as a fiery volcanic mass from deep in the earth's interior into the base of what, at that time, were giant mountains occupying much of what is now England's south-western peninsula. The granite deep within the mountains solidified and hardened, as did further veins within it, containing, crucially for the human future, molten tin and copper ore. Then, over unthinkable periods of time, the mountains themselves were worn away to leave no more than the granite intrusion at their base, mere stumps by comparison. These are the hills and tors of Dartmoor. It is indeed the first principle of the English moorlands that they remain because they consist of the rock with the greatest powers of resistance. Nor is it too fanciful to see in this circumstance the deepest inner nature of the moors.

Then there is the wetness, another essential aspect of the moorlands. Boulder clay formed from decomposing granite helps to hold the water. So do the peatbogs, incorporating the remains of local plant life, preserved by the prevailing acidity.

Yet rivers do eventually escape from the moors, coursing away downhill through valleys of exceptional loveliness, usually, in our day, containing farm and forest land. Given that the moors themselves consist largely of the most resistant rock, they would tend to be rocky plateaux if it were not for the action of water. This produces individual hills and peaks simply by finding out each weakness in the rock and using that to carve a course towards the sea. Thus, in their tender greenness, the valleys become an inseparable part of the moorland landscape.

Dartmoor, even more than Bodmin, is pierced and ringed by the loveliest of riverine

ABOVE:
Moorland vegetation thrives on the moist, acidic soil of Dartmoor.

OPPOSITE PAGE:
Wild ponies have roamed on Dartmoor for centuries.

landscapes. One need only mention the River Dart itself, descending in a ripple of granite and white water, down and down, through oak woods and eventually green fields, to the dark tidal mudbanks of its estuary, to give a first impression of the beauty of the valleys. Exmoor, lying just a few miles to the north, is possibly even lovelier in this respect. Here, unlike the underlying granite of its neighbours, the moorland rock is a hard sandstone, formed as a sediment in age-old seas. This produces flatter hilltops than Dartmoor's, covered with heather and bracken, grazed by the only red deer to survive on English moorland, and marked by lines of beech trees round small pastures — these last were planted by nineteenth-century "improvers". But out of Exmoor's flattish tops the waters pour with enormous vigour, gouging spectacularly deep valleys heavily grown with gnarled old trees, and slicing down to the nearby sea through a coastline of high cliff. So fierce is the water flow at times that even such settled little towns as Lynmouth at the foot of the Exmoor cliff have suffered disastrous floods and loss of human life within quite recent memory.

It is a curious fact that the West Country moors, despite their eroded appearance, were not changed to any great degree by the Ice Age. The ice sheets that episodically covered Britain up to about 12,000 years ago came down only as far as the Bristol Channel. Valleys trenched by water, not by ice, tend to be a simple V shape, as is broadly the case with the West Country moors. In England's more northerly moors the ice has often scraped away all soft material, leaving a wider U shape rising from a flatter valley. As any visitor to the northerly Yorkshire Dales will note, this produces a quite specific combination of moor and valley, instantly recognisable, always compelling.

FROM THE MOORS OF THE WEST COUNTRY TO THOSE OF THE NORTH IS ESSENTIALLY A LOWLAND journey, passing, if you should choose to, through the Somerset Levels, then working up eventually by Birmingham and over the Midlands plain until once again the land begins to roll and the southern end of the Pennine hills comes into sight. The loosely connected Pennine chain, cut through here and there with gaps and passes, gives a home to most of England's

OPPOSITE PAGE:
In this view from Holdstone Down, Exmoor, the moorland edge drops straight down to the Bristol Channel.

PAGE 16:
A road enters the tangled woods near Cloutsham, Exmoor.

PAGE 17:
Moor and high pasture sweep away from Dunkery Beacon, the highest point on Exmoor.

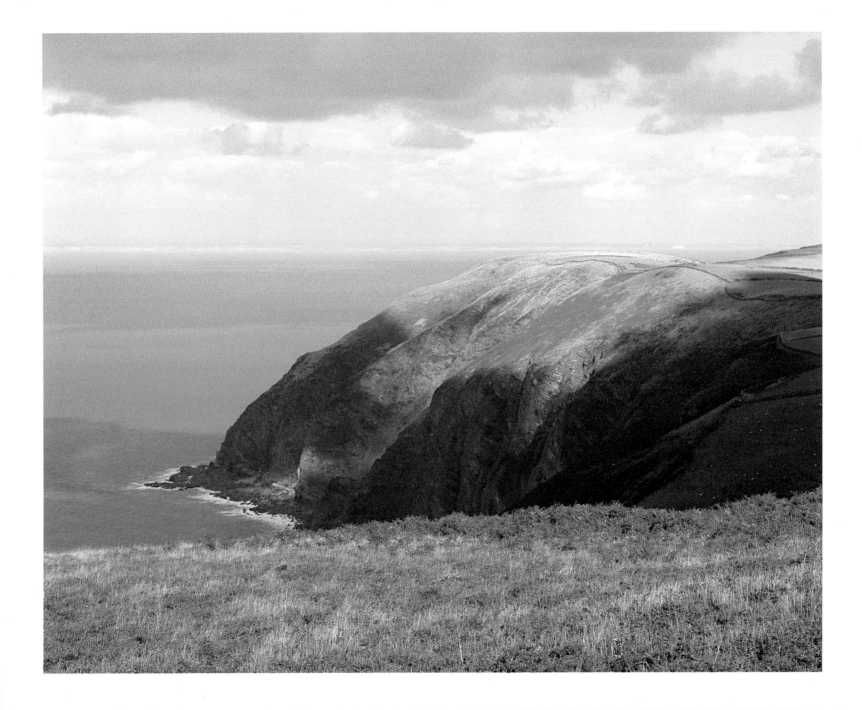

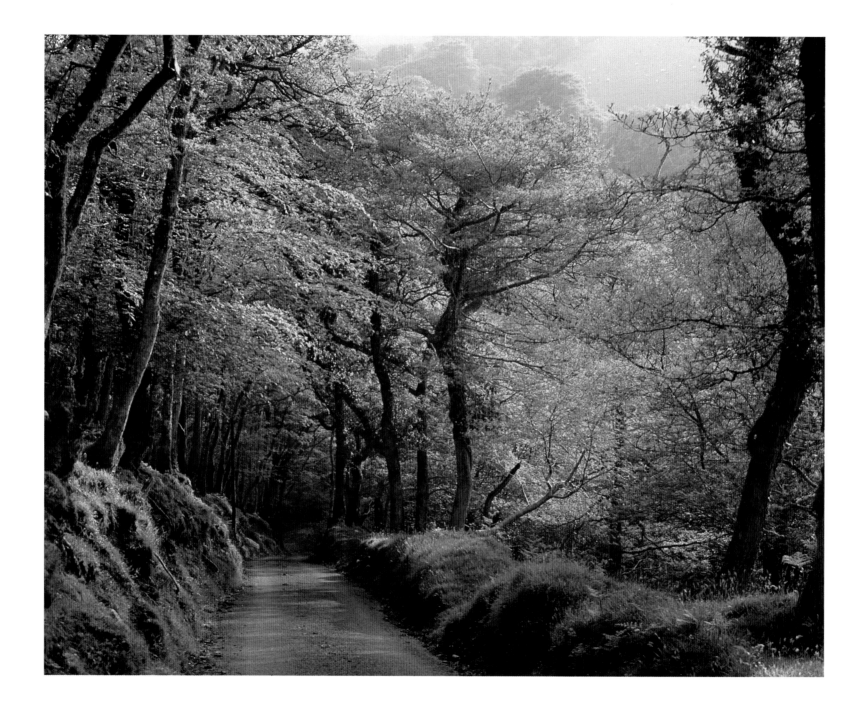

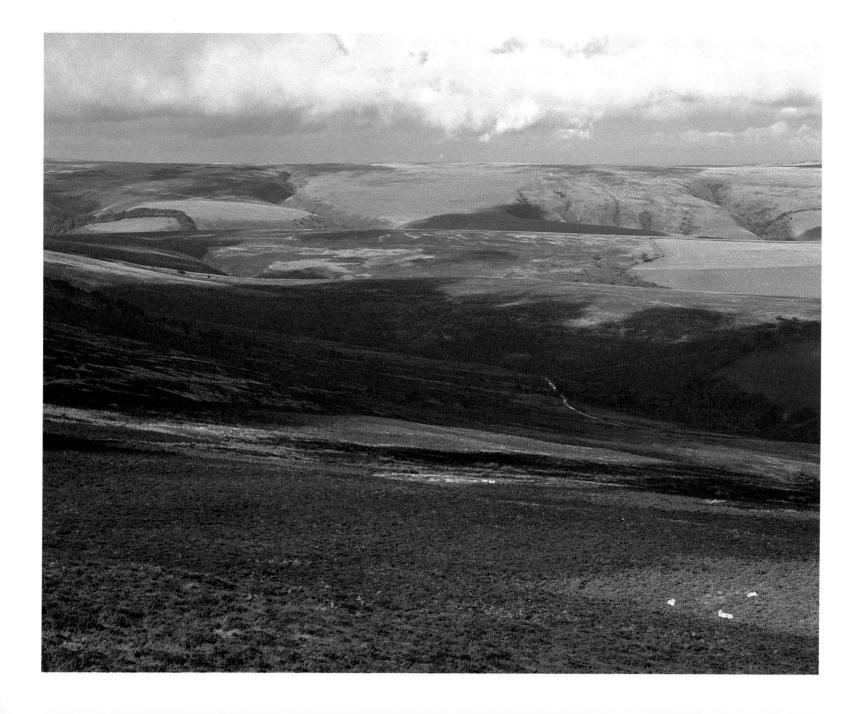

moorland, from the Peak District, through the milling towns of Yorkshire and Lancashire and right on up by way of the Yorkshire Dales to the lonelier, wilder, wider moors of Durham and Northumberland.

In the Peak District, first in the long line of moorlands, the Pennines instantly offer a kind of sharp one-two, a boxer's knockout punch of grey-white limestone and hard, dark millstone grit. The Peak District is arranged in fact in the shape of a boxer's glove laid on its back, with the limestone corresponding to the palm, open at the wrist to the Midlands plain, but ringed around on its east and north and west by the darker bulk of millstone grit. This is the rock from which millstones and grindstones were traditionally hacked, a kind of extra-hard sandstone, as rough to the touch as sandpaper. You can climb up from the Midlands either on to limestone or straight on to gritstone, but either way the change is astonishingly abrupt. What you will also notice, from the bottom of the Pennines right up through the north of Yorkshire, is the striking prevalence of stone walls. Light or dark depending on the rock beneath, and always built "dry", without mortar, they mark out fields and pastures in the valleys. Then, squiggly or straight, they go right on up the side of even the steepest hills, sometimes all the way to the moorland summits.

The limestone country in the south of the Peak District is ushered in by soft, green hills. These soon give way to white, rocky outcrops, triangular calluses of hill, and rocky ridges cleft by dramatic gorges. Trout streams like the Dove and Manifold, immortalised back in the seventeenth century by Izaak Walton and Charles Cotton in their *Compleat Angler*, come running out of the limestone country. Cotton himself came from a grand home on the limestone plateau up above these rivers and went to church in a village fittingly named Alstonefield.

Should you pass from the Dove across the tableland and valleys of the lime interior, mostly made up of grassy pastureland, you will in due course find yourself crossing a genuine moor of entirely darker aspect, with heather and cotton grass unlimited. After a while, if travelling north-west, you may well come to the Mermaid Inn, a single building on a

OPPOSITE PAGE:
The English Midlands meet the North at these first crags of millstone grit. This view from the Roaches overlooks Hen Cloud in the Peak District.

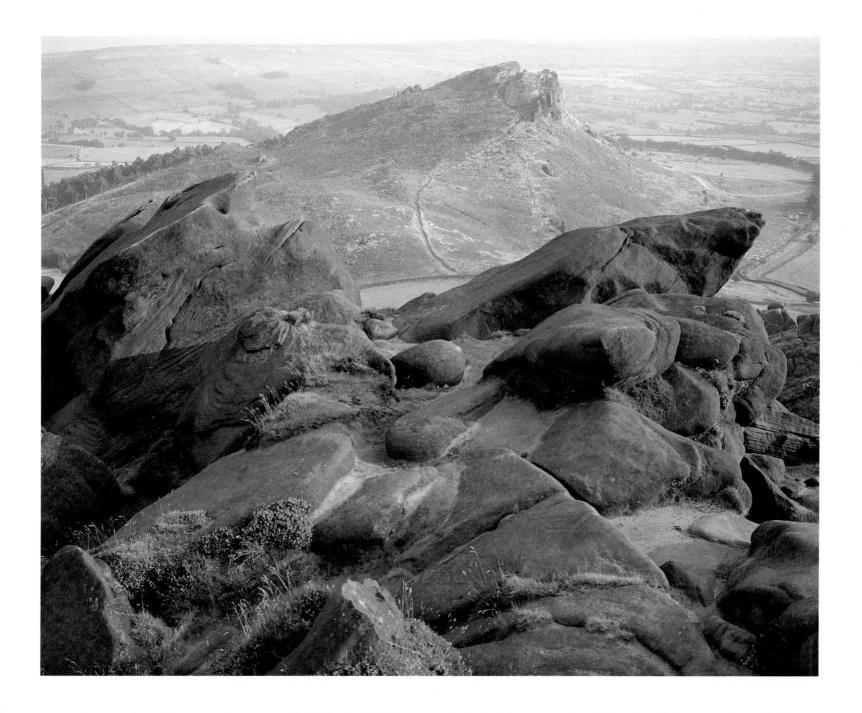

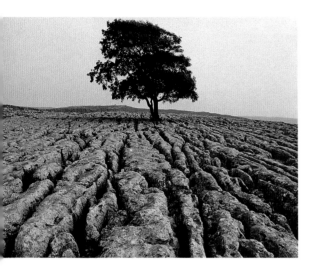

ABOVE:
These deep fissures in the flat limestone pavement near Gordale Scar in the Yorkshire Dales are caused by the action of water.

barren-looking skyline. Below and stretching to the sunset is an extraordinarily changed landscape, marked by dark rock spires and lizard-like displays of rocky spine, with lines of cliff, or "edges", along the top of hills.

This rocky frontier-land is what you first confront if you come up from the Midlands directly on to gritstone — Hen Cloud, the Ramshaw Rocks, the Roaches, schooling ground for some of Britain's finest mountain-climbers. Similar cliffs and edges, longer though often less spectacular, and rocky tors remarkably like Bodmin's Cheesewring, mark much of the gritstone country that lies around the lime. Perhaps the most remarkable of all are the many points where the two landscapes meet, providing a dramatic shift of colour and contour, with villages built in a medley of both stones, as well as the softer sandstone that sometimes intervenes. One of the wonders of the district is Mam Tor, sometimes known as the Shivering Mountain. It stands right in the frontier zone and is continually eroding, through landslip after landslip. The main road under is now permanently closed, obliging traffic to climb up instead through a winding limestone gorge immediately adjacent. Here, at the top, in the valley under Rushup Edge, the gathered waters of the uplands simply disappear into a cavern — another feature of the limestone country. Not surprisingly this is cave country, beloved of pot-holers.

Even when you know the Peak District thoroughly, it remains an astonishment that its upland moors and rocks somehow retain so much wilderness. The whole area is in practice small enough to allow you to peer down on one side from the Burbage Moors on to the gabled suburban roofs and office blocks of Sheffield, and on the other, within the hour, to the stilled mill chimneys and cobbled streets of the old centre of Macclesfield on the far side of the Pennines. Manchester is practically within a stone's throw and Huddersfield no further. Yet it is here that the Peak District moors are wildest and emptiest, with the Pennine Way, most famous of England's long-distance footpaths, striking out northwards from Edale across the formidably drear plateau of Kinder Scout. Bleaklow, Saddleworth and Meltham — these are moors that test the legs and psyche, a genuine wilderness among the cities. You can put down their survival in part to conservation, giving some credit to the National Parks that

are centred on each of the major moorlands. But you have to put it down as well to the dour resistance of the rocks beneath.

It was the peat, not the rocks, that in a real sense brought in the industry and made the cities grow around the moorlands. The peat retained the water that fell on the wide slopes until finally it burst forth in little upland streams, gathering to upland rivers strong enough to power the wool and cotton mills of the eighteenth and nineteenth centuries. The mills flourished above all in the outer valleys of the moors. This you will see as you move north from the Peak District, through such busily dramatic moorside towns as Holmfirth, capital of television's "Summer Wine" country, through Halifax, Bradford, Bingley, Keighley, even Haworth, that dark and stone-built moorside village where the Brontë family was to pour out its torrent of imaginative frenzy. The dense overlay of industry along the valleys here makes a kind of waist-band on the Pennine hips, pinched in at the Airedale Gap to allow the passage not just of road and railway but of the Leeds–Liverpool canal, which climbs up through the Bingley five-rise locks to Skipton, to cross the central spine of England.

It is only after the canal-crossing at Skipton that industry starts to recede from the moorland interstices and one can begin to feel the onset of the Yorkshire Dales, with another marvellous limestone entry. For here the limestone itself has shifted, along the so-called Craven Fault, to create a series of high, white cliffs and crags, a kind of inland Dover. It's as if the Pennines at this point had changed into a vast rabbit, turning with scut exposed to run away due north, leaving the viewer open-mouthed. Malham Cove, to take the best-known instance, is a great limestone cliff face, heavily overhanging and carved into a curve by a now-vanished waterfall. Down below tourists and local visitors, many of them schoolchildren, attend in cheerful thousands; above, all is immediately upland, walker's country, with crag and cliff and gorge, the Pennine Way running through, and plenty of that extraordinary phenomenon known as limestone pavement.

Basically, this consists of a broad spread of limestone rock, maybe waist high above the surrounding ground, cut into myriads of blocks by the action of water and all the other

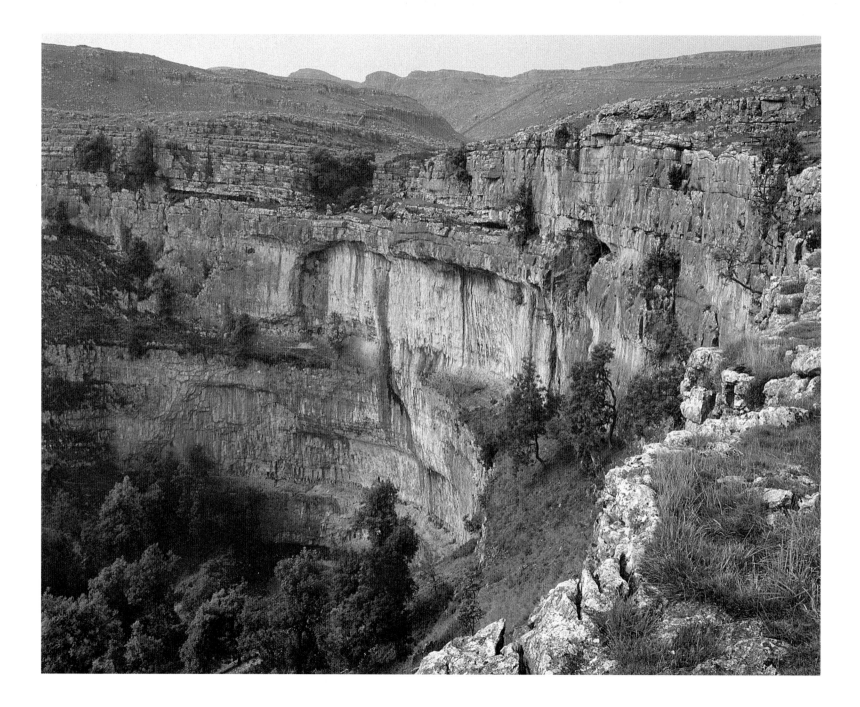

forces of erosion. The blocks are known as "clints". The cracks and crevices, waist deep, narrow and therefore shaded, carry the evocative name of "grykes"; deep within them flourish ferns and nettles and all the woodland flowers of ancient forests. The limestone paving is beautiful and laughable, wonderful to clamber on.

Here and there, at other points in the Yorkshire Dales, the limestone once again breaks the surface, sometimes forming long lines of whitish cliff. The rivers are full of small cascades and often you will meet a larger waterfall, known as a "spout" or "force". Invariably, though, the limestone drops out of sight on the very highest hills. These, like the higher grounds of the Peak District, owe their considerable height — and their survival — to a hard cap of millstone grit beneath the surface peat. Whernside, Ingleborough and Penyghent, all over 2,000 feet, are the big hills of this region, forming a magnificent backdrop to the Settle–Carlisle railway as it passes over the highest moorland run in England.

The moors themselves spread wide over the heights between the dales, the steepness of ascent and the considerable width on top discouraging easy movement between the valleys and helping to keep them separate in atmosphere and ethos. Certainly they look surprisingly different. Wensleydale is the broadest and the flattest. Swaledale is deeper and narrower. Arkengarthdale and Langstrothdale climb high up into open moorland. Wharfedale, cutting down diagonally towards the south-east corner of the highlands, adds another interesting phenomenon, also to be seen at the upper end of Bishopdale. Here, before the Ice Age, the valleysides were formed of layers of limestone alternating with broad bands of shale. Being soft, the shale was scoured away by the action of the ice, and its absence is marked today by flat and grassy plateaux alternating with steeper pitches formed by the limestone. Why the resulting profile of the hill, all bumps and flats, should look so beautiful is mildly mysterious, but beautiful it appears to all who see it.

From these clustered valleys of the Yorkshire Dales, the moors immediately run northwards into Cumbria, Durham and Northumberland, ever wilder, ever more solitary. Meanwhile, away on the west side of the Dales, the Pennine rock gives way to extremely

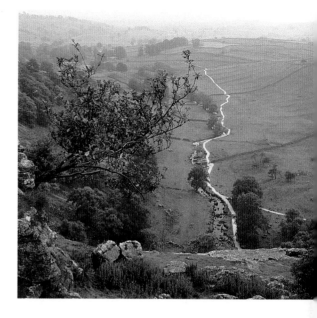

ABOVE:
Looking down from the cliff of Malham Cove in the Yorkshire Dales at a well-kept path for the thousands who flock here.

OPPOSITE:
Malham Cove in the Yorkshire Dales was carved out of the limestone by a long-vanished waterfall.

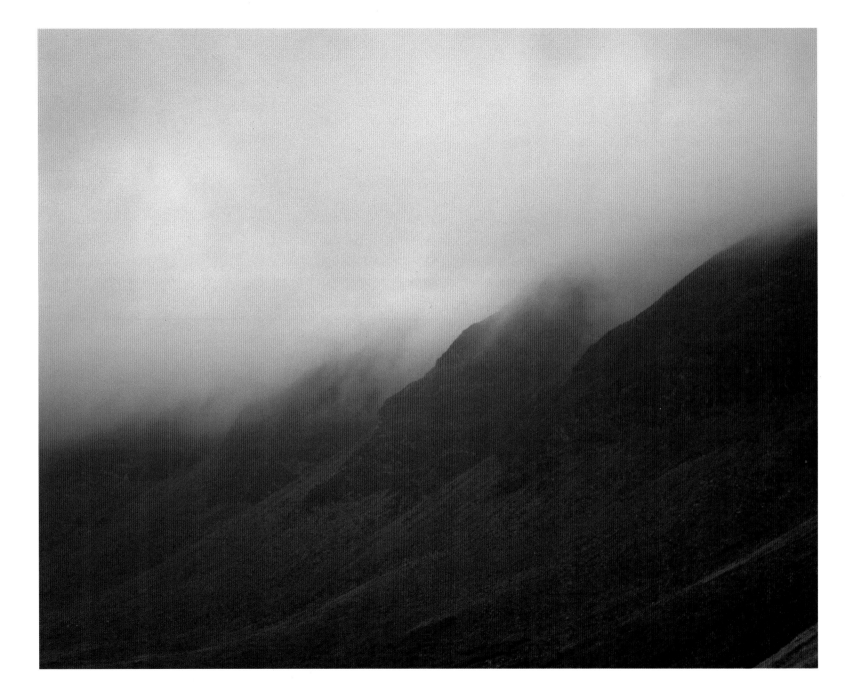

ancient and deeply folded slate, the basic constituent of the Lake District. The Lake District itself is mountain rather than moor, but just between the lakes and the dales proper, the folded slate throws up a group of moorland hills, the Howgill Fells, home of high waterfalls and exhilarating walking.

The North York Moors, perhaps the best-loved of all in England, occur at just about the same point as the Howgill Fells on the north-south axis, but to the east of the Pennine chain and separated from it by the Vale of York. This means there are three chunks of moorland running from west to east across this point of England — the Howgill Fells, the Yorkshire Dales and finally the North York Moors. The North York Moors are the youngest of the three, in fact the youngest moors in England. Here the underlying rock is mostly a Jurassic sandstone, formed when dinosaurs roamed the earth. Over the sandstone grows the greatest single expanse of heather in all England. A skein of walls rises up to the moors within the farming valleys, often enclosing the smallest of fields. Wild daffodils crowd along the sides of streams in springtime. Finally the moorland meets the sea, running to a line of high, wild cliff and simply stopping. The whole, once again, conveys an apprehension of eternity.

Here, perhaps, we experience a paradox that must itself be part of the nature of the moors. For the sense of infinity evoked by the moors is undoubtedly real, and the wildness and severity are also real, appealing as they do to the wilder places in our inmost selves. But England itself is just one part of a modest island and the moors, in any non-insular overview, are genuinely tiny. Are they perhaps, in their physically small scope, a better measure for ourselves, more fitting to our human stature in their limitations, than the Canadian Arctic or the Australian outback? Perhaps, to compare great things with lesser ones, the moors are as small and vulnerable as we are; and once this thought has occurred, it cannot help but make us tremble for their future.

OPPOSITE PAGE:
Howgill Fells, on the way to Cautley Spout.

CHAPTER TWO

FIRSTCOMERS

THERE WERE NO MOORS AT ALL WHEN HUMAN HUNTING PARTIES FIRST MOVED ON TO THE ENGLISH uplands about 10,000 years ago. The hunters were following big game as it moved north after the receding Ice Age — red deer and roe deer, wild horse, wild boar and the aurochs, that primitive breed of cattle now long extinct. Their only domesticated animal was the dog, useful in scenting out their prey, for what they found on most of the high ground was forest cover, mainly hazel and oak. Indeed, the River Dart and the two Derwents all take their name from the Celtic word for oak. Only the tops of the Pennines, and Dartmoor at over 2,000 feet, were comparatively open, with clearings, set among tangled thickets, on the highest ground. But the early arrivals in these high places, the so-called hunter-gatherers, soon began to make an impact on the landscape, extending the clearings by burning. The idea, it seems, was to attract the game to predictable grazing places.

The evidence for burning, the first form of land management on the future moors, seems reasonably clear. On Dartmoor, for example, charcoal has been found at the lowest levels of present-day peatbog. One effect of the burning may have been to start, however faintly, a process by which minerals and nutrients leached away to lower ground. In some places there were no longer enough trees to take up water. Marsh formed as a result and led to the slow growth of peat, which is created by an accumulation of dead plant-matter, preserved by acid wetness.

Oliver Rackham, historian of the British countryside, implies that the peat might have come into existence anyway in the wetter soils of the west and the Pennine tops, and argues that human agency has probably done little more than speed up natural processes. Our forebears, he believes, came to the English uplands along with wind and wet and all the other forces of evolution, and the combination of these forces, not any one alone, produced the moors we know today.

OPPOSITE PAGE:
The stunted oaks of Dartmoor's Wistman's Wood, an endangered prehistoric woodland.

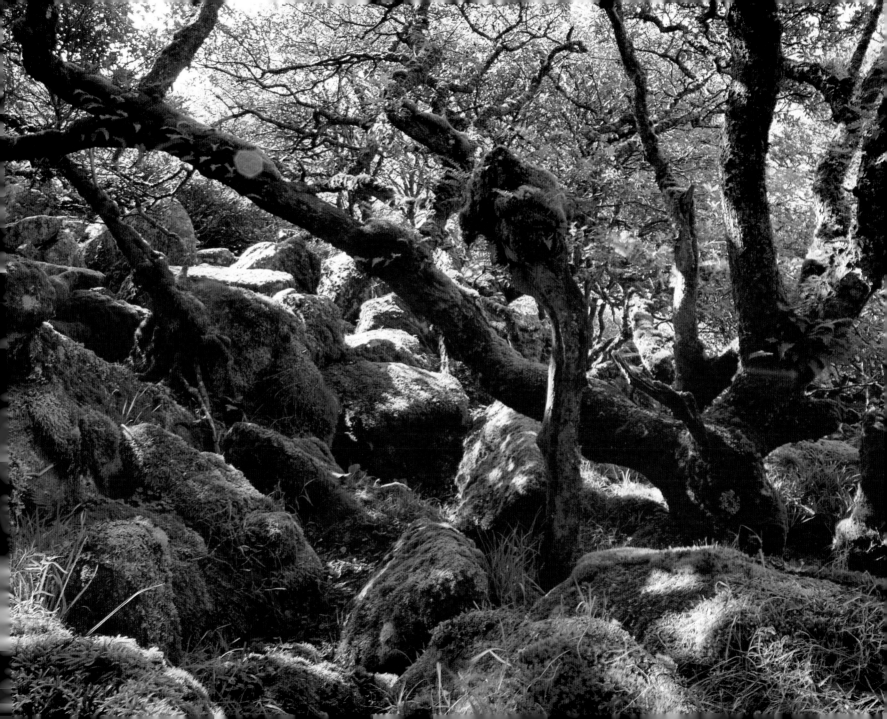

Even while accepting the need for caution in attributing too much to mankind, we can certainly date the earliest human contribution to the moors to the hunter-gatherers and their burning practices. It is even possible they killed too many of the large animals they hunted, just as the cave-painters of Lascaux and Altamira appear to have done. The delicate flint arrowheads of the British-based hunter-gatherers, which are found from the Pennines to the West Country, grew smaller and more delicate with the centuries.

Farming, in Britain as elsewhere, eventually replaced hunting as the major human occupation. We recognise the presence of the farmers, often living alongside the lands of the dwindling hunter-gatherers, by the presence of cereal pollen in peatbogs, by the bones of domesticated animals, by charred remains of food, by pottery (which they possessed while the hunter-gatherers did not) and by the quantity of stone axes used for forest clearance and ceremonies. Even if the basic artifacts seem fairly simple, there is no question that their lives were complex and sophisticated.

The most telling evidence on this comes from the wetland moors of the Somerset Levels — thanks, once again, to the preservative powers of peat. It involves the discovery of the oldest known wooden trackway in Europe.

A YOUNG CAMBRIDGE ARCHAEOLOGIST, JOHN COLES, SPENT THE 1960S INVESTIGATING THE Somerset Levels, working closely with university botanists and specialists in radio-carbon dating. Then, in the early spring of 1970, an unusual parcel reached him at Cambridge. It contained a piece of ancient ash plank so intriguing that Coles, as he puts it, "hastened to the Levels". The finder of the plank was a peat cutter named Raymond Sweet and so, as spring turned to summer and a major dig developed, the trackway that was progressively revealed was given the name of the Sweet Track.

John Coles met his future wife and collaborator, Bryony Orme, during the course of the first dig and from that season, year after year, they and their close colleagues devoted themselves to fresh discoveries. These, in archaeological terms, were cumulatively

spectacular. First of all, it turned out that the Sweet Track was much, much older than other trackways already found in the Levels. The investigators were eventually able to show that all the thousands of pieces of timber that went into its construction had been felled in the single winter of 3807–3806 BC. The tools that had been used were those of farmers, indicating that the first farmers were present very early on.

Physically, the track was simple enough. Poles were first laid along the surface of the marsh between two islands, often slightly underwater. Stakes were driven in diagonally from either side to hold the poles in their position. The crossed diagonals formed a V into which a pair of planks about 20 to 30 centimetres across were squeezed, providing a narrow and somewhat precarious walkway. Anyone who started out along the track would soon be hidden by high reeds.

If the construction was practical and direct — the Coles believe that the two kilometre trackway could have been assembled by ten workers in a single week — the operation as a whole must have been complex. The cutting and preparation of the timber (conducted on two separate sites at either end of the trackway) would have required cooperation between two groups of people. There must have been a plan, possibly some kind of sketch to work from. The result was an eminently practical way of crossing from one island to another.

Since nobody seems to have lived at either end, the purpose of the track remains obscure. Arrowheads found along the way suggest that it was used in part at least for hunting — then, as now, a part-time occupation for farmers. There is also broken pottery, presumably dropped by people using the trackway. One jar held hazelnuts, and one was associated with a stirrer, suggesting that whoever let it fall may have been eating gruel. Most fascinating of all was the presence of two axe-heads, one made of jadeite and never used, deposited intentionally beside the track in some unfathomable act of reverence or propitiation.

The track only had a life of about ten years before it fell into disrepair and was abandoned, to be hidden for millennia by reeds and then by peat. So it might have lain for thousands of years more had it not been for modern methods of peat extraction. Old-fashioned nineteenth-

century peat working had not got down much beyond Roman times. But today's deeper, mechanised digging reaches the earliest levels of peat formation. At the same time, general drainage of the Levels threatens to dry out and so destroy the human artifacts, especially wood, that had been preserved in the wet peat. This destructive state of affairs means that whenever ancient remains are found, urgent excavation is demanded. The pity of it is, as Bryony and John Coles have pointed out, that the wood that comes up from the deeps cannot survive in the condition of its recovery. Wetland excavation ends "with an empty site and a laboratory full of wood".

NOT SO, HOWEVER, WHEN THE BUILDING MATERIALS ARE STONE AND EARTH ITSELF. FOR NOW the moorland story moves back to the uplands and to the prolific human testimony that is still written there, in granite, lime and gritstone and in sometimes quite enormous earthworks.

You can hardly step out on the upland moors today without feeling the pull of an ancient presence. Stand on Kestor Rock on Dartmoor and look around and you will see on one side prolific hut circles, stone footings now sunk into the earth but still knee-deep inside. On the higher ground you will make out standing stones and single megaliths, conveying a deep sense that the whole landscape has been staked out in granite by our forebears. Visit Merrivale or Grimspound on Dartmoor, and the impression is even more intense, with the remains of ancient communities riding out far higher on the moor than present-day farming can achieve. On Bodmin Moor, you have only to stand a moment on the summit of Brown Willy and you will see from the hut foundations and long-abandoned field boundaries below how profuse was ancient human activity.

Conan Doyle caught the atmosphere brilliantly in *The Hound of the Baskervilles*, his tale of terror and skulduggery on Dartmoor. Dr. Watson, you may remember, had gone down to the moor from London on behalf of Sherlock Holmes and in his first report writes:

OPPOSITE PAGE:
Scorhill Circle, Dartmoor. Often such stones provoke more questions than answers.

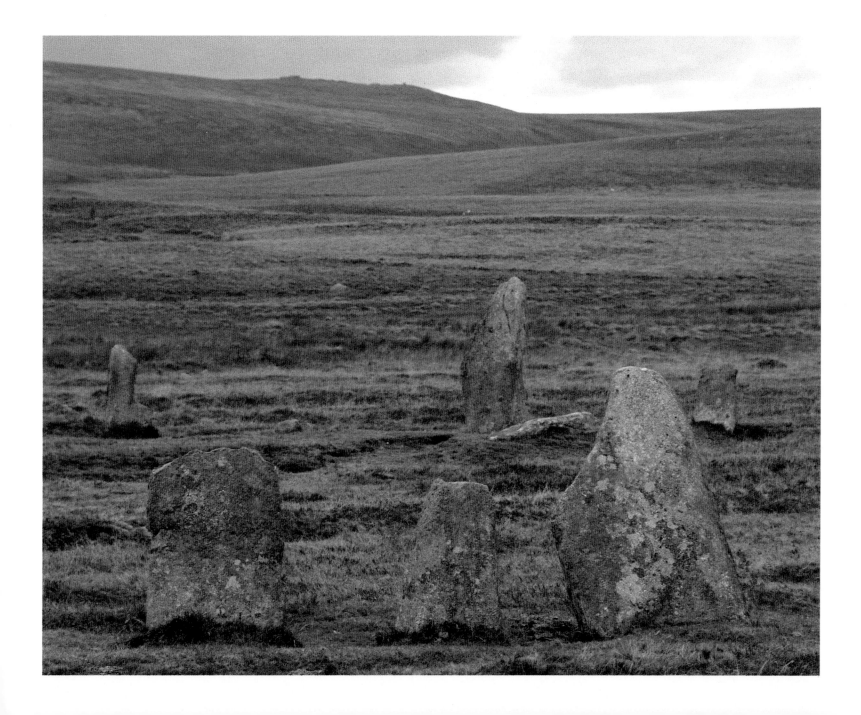

RIGHT:
Kestor Rock, near Chagford on the eastern edge of Dartmoor, is one of the West Country's great survivors.

OPPOSITE PAGE:
When the bracken is lower, numerous hut circles are visible within the perimeter wall of Grimspound, the Bronze Age settlement on Dartmoor.

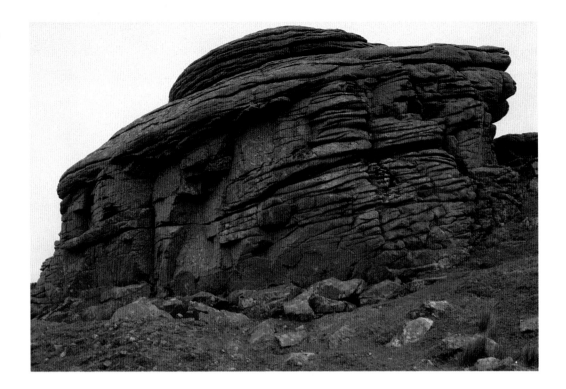

The longer one stays here the more does the spirit of the moor sink into one's soul, its vastness and also its grim charm. When you are once out upon its bosom you have left all traces of modern England behind you, but on the other hand you are conscious everywhere of the homes and the work of prehistoric people. On all sides of you as you walk are the houses of these forgotten folk, with their graves and the huge monoliths which are supposed to have marked their temples. As you look at their grey stone huts against the scarred hillsides you leave your own age behind you and if you were to see a skin-clad, hairy man crawl out from the low door, fitting a flint-tipped arrow to the string of his bow, you would feel that his presence there was more natural than your own. The strange thing is that they should have lived so thickly on what must always have been most unfruitful soil.

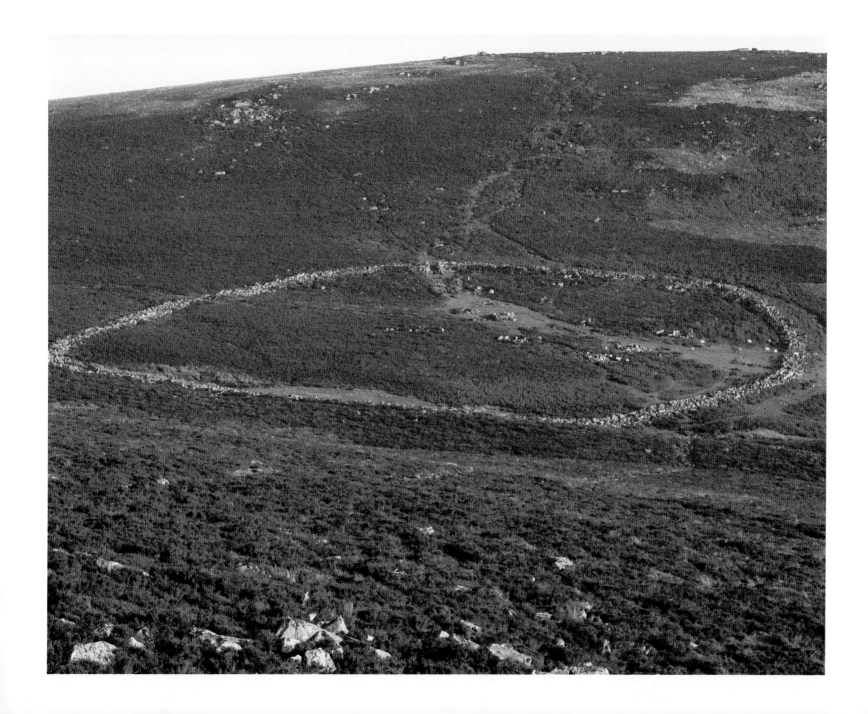

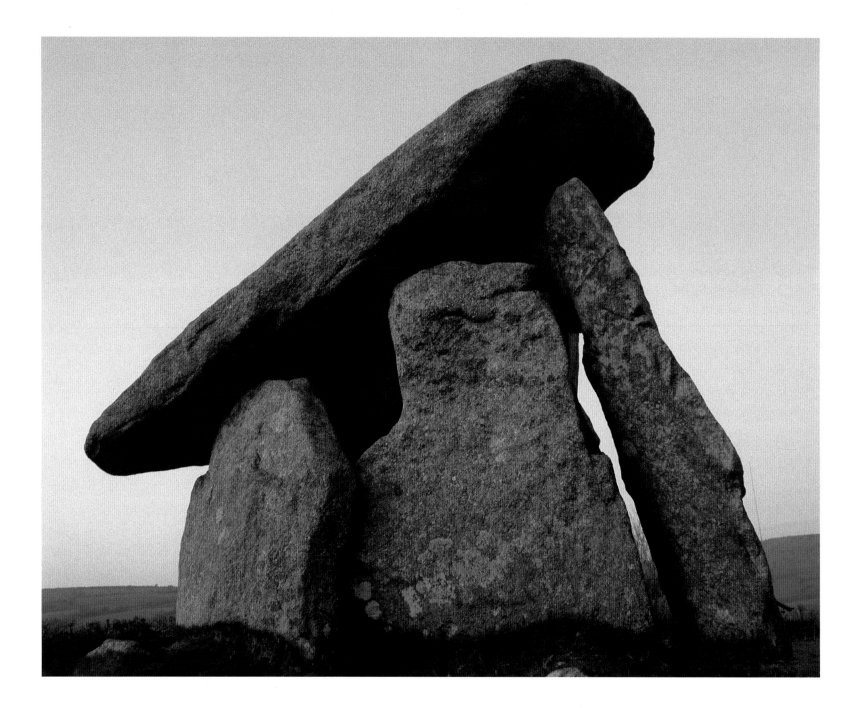

Archaeology has moved on dramatically since Conan Doyle wrote these words and almost everything that is said today challenges the notion that the inhabitants of Dartmoor, and by extension of the other uplands, were either primitive or simple. Quite the reverse — this long, long prehistoric period from the Neolithic to the Bronze Age saw the future moors of England at their busiest, most settled and most prosperous, reaching a high point about 2500 BC to 1200 BC. This was undeniably the major phase of human activity on the British uplands, including our own times.

It seems, to pick the tale up not so long after the times of the Sweet Track farmers, that the uplands were still extensively wooded, with wildwood now returning even to the parts that had been cleared before. At all events, the homes of neolithic farmers are seldom found, first because they were built of wood and second because there was no peat to preserve the wood in the areas they inhabited. What the early farmers have left in abundance are their tombs, at first long barrows and cairns with burial chambers in them, often built up above the limits of their farmland, at valley heads or at the tops of ridges. The North York Moors, the White Peak — that is to say, the limestone region of the Peak District — and Exmoor specially are well supplied with these. The barrows are not particularly dramatic to look at but they are of great significance in the human story. It seems quite probable that they marked territorial limits, associating the ancestors of the community with land the clan regarded as its own in perpetuity. The size of the barrows seems to have reflected great reverence for the ancestors, maybe even ancestor worship.

In the West Country, where surface stone was plentiful, and specially on Bodmin Moor in Cornwall, the ancestors were celebrated with handsome chamber tombs or dolmens, tall boxes made of stone, topped with a single mighty block known as a capstone and then covered over with earth. Nowadays, the earth has invariably been removed, along with the contents, leaving just the stone structure standing, weirdly impressive and sometimes surprisingly tender. There is one at Trethevy Quoit, in Bodmin, in the corner of a field, with the modern houses in the lane seemingly almost touching it. In a child's bedroom, teddybears

OPPOSITE PAGE:
Trethevy Quoit on Bodmin Moor.

lean against the window, hardly five paces from the protective ancestors.

Little by little the upland forests were felled or burned, this time to clear the ground for stock rearing and crops. The felling is closely tied in with the next phase in the construction of major monuments. These included not only many thousands of burial barrows, but more importantly a great number of upland stone circles, single markers and stone rows. These depended on clear sight-lines and would have made no sense until the forests were felled.

Astronomy lay at the heart of the matter, with many obvious alignments of the stones, particularly with sunrise and sunset at midsummer and midwinter. Whether the alignments went further than this has been deeply controversial. Some have claimed that the standing stones also carry a bewilderingly numerous array of lesser stellar and planetary alignments, depending, seemingly, on exact astronomy and abstruse mathematical calculation.

The idea that our ancestors were powerful astronomers has become associated with the further notion of geomancy and earth-magic, associated in turn with the idea of "ley-lines". The supposition is that the landscape is full of special linear forces, which still exist and of which our forebears were already well-aware. For those people who look back not to Conan Doyle's "primitive man" but to a golden age of secret knowledge, the notion is deeply pleasing. The actual evidence for the multiplicity of astronomical alignments, however, let alone the question of ley-lines, does not appear at present to go a fraction of the distance. Yet one need not be entirely disappointed, for the solar observation is in itself impressive and carries the clear suggestion that the main purpose of the circles was to do with ritual based on the heavens — enough, surely, to satisfy imagination.

Bodmin, prominent as usual in all matters of stone, has some particularly intriguing circles and standing stones. One of the best known is the Hurlers, close to the village of Minions, where three circles still stand, well-spaced, in frozen mystery. Six other circles on the moor offer clear astronomical alignments, with a line-up between particular standing stones, at equinox sunrise and midsummer sunset, and the summits of tors along the horizon.

One of the most pleasing of all upland stone circles is that at Arbor Low on the White

OPPOSITE PAGE:
A standing stone on Shovel Down, Dartmoor.

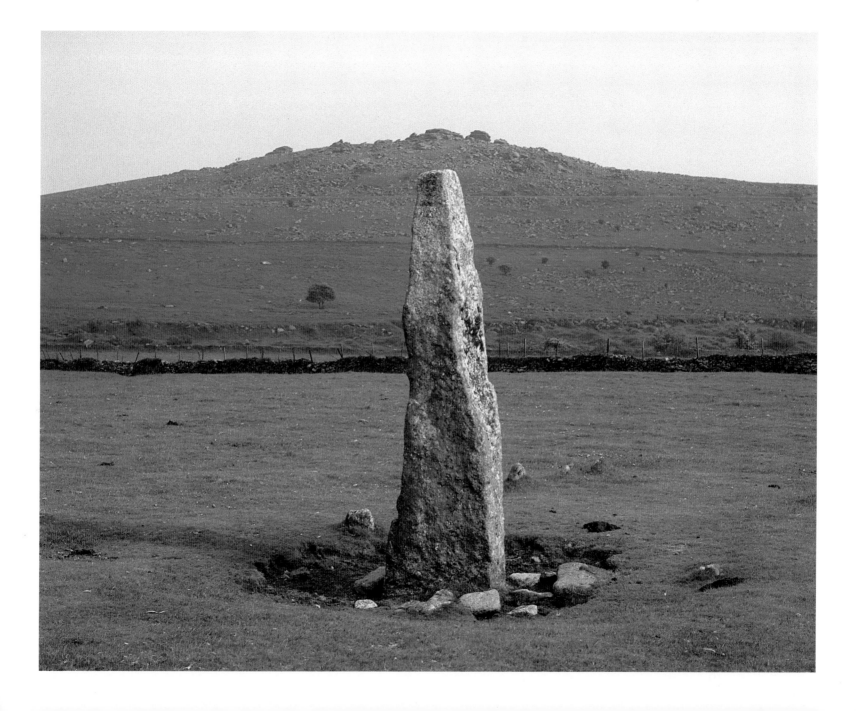

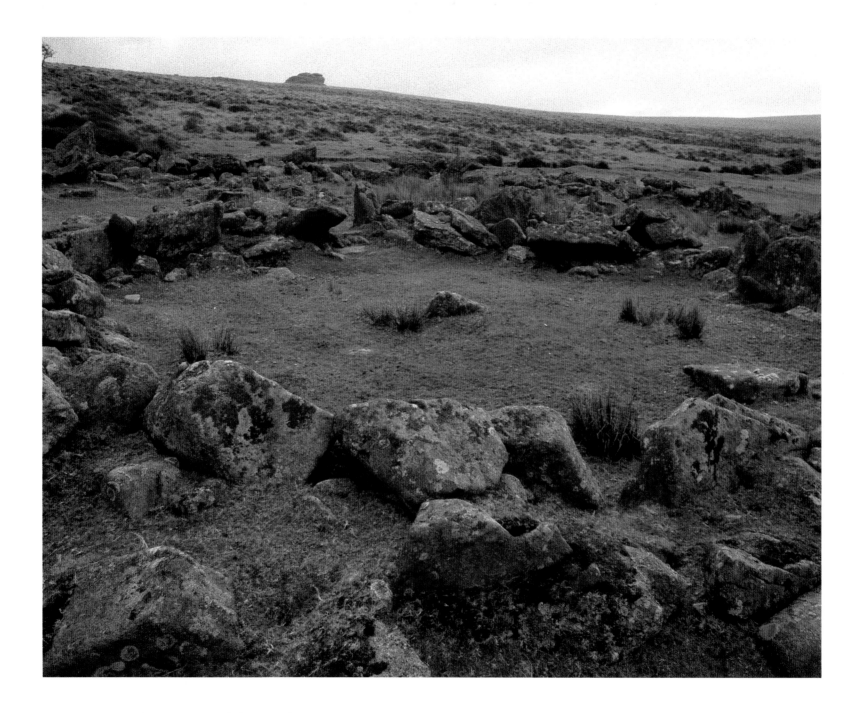

Peak of Derby. This magical place, the highest stone circle in Britain, lies a short way below the summit on a gentle slope. What marks it out from all the others is that the stones lie prostrate on the ground, either never erected, as some believe, or far more probably destroyed in a deliberate act in later centuries. There, at all events, lie the great stones, grey-white in the greensward, conveying a deep sense of ease and peace. Around the circle is a broad ditch, crossed by two simple causeways, and beyond the ditch there still rises a rampart of earth. This is the classic arrangement known as a henge, the ditch being inside and not defensive.

Stone circles were starting to go out of fashion by about 2000 or 1800 BC. Perhaps, as some believe, society could no longer steer itself by ritual and more direct forms of social control were needed. This was the age of the hundreds of stone hut-footings we see on Dartmoor. Growing evidence suggests that far from wearing the skins of Conan Doyle's description, the inhabitants wove and wore their own woollen clothes. Stock rearing gave them meat and milk as well as wool. They also managed their surviving woodlands carefully, using the system known as "coppicing". In this, underwood trees are cut back, producing huge boles or "stools" from which straight poles grow up, available for easy harvesting and charcoal-making. The timber for Somerset's Sweet Track was probably produced this way and other Neolithic farmers, on Exmoor for example, were clearly expert coppicers.

MEANWHILE, ON DARTMOOR, SOMETHING ELSE WAS HAPPENING AND ON AN AMAZING SCALE, challenging any notion of small groups settled comfortably in individual farming communities. This "something" was the construction of massive boundary walls. In this highly organised large-scale land-division, whole groups of individual territories had clearly been aligned along a single axis, then further subdivided into enclosed fields and open grazing land. The inescapable conclusion is that there was a master-plan of land-division that must have come from a central power structure. The moors must surely have been surveyed, the line of walls been planned, and finally the boundary division imposed. There is evidence, as we shall see, that similar arrangements were put into force on other future moorlands. There

ABOVE:
The prostrate stones at Arbor Low, the highest stone circle in England, still attract tributes from visitors.

OPPOSITE PAGE:
The moor abounds with stone circles, ranging from Bronze and Iron Age hut footings to medieval cattle pounds. This one is near Batworthy, Dartmoor.

are also suggestions that the same system prevailed in lowland agriculture, though contemporary deep ploughing has by and large removed the evidence.

The curious thing, in the case of Dartmoor, is that none of this had been fully recognised or its implications appreciated until some 20 years ago, even though the walls lay right there in the form of linear turf-covered mounds, dense packed with stone within. Sometimes stone was showing where walls had been broken. The presence of some of these vast boundary works had indeed been noted in the nineteenth century, but after that, it seems, entirely forgotten. Perhaps, because their date was indeterminate, curiosity was scarcely roused. But by the 1970s amateur archaeologists had rediscovered part of the system and recognised it as far more "ruthless" than anything suggested by the humbler boundary divisions of the medieval period. The walls, known locally as "reaves", must have been built sometime between the early Bronze Age and about AD 1000, the amateur archaeologists believed. But after that, they were at a loss.

True recognition was left to Andrew Fleming, an archaeologist at Sheffield University and, earlier, a collaborator on the Sweet Track project. Eating his sandwiches one day on Dartmoor, in a prehistoric walled enclosure, he and a colleague became so curious about the reave that ran away from it that they began to follow the line. Very soon they encountered a D-shaped Bronze Age dwelling that used the reave as its back wall. In other words, as they instantly realised, the wall had been there first and must have dated from at least the Bronze Age. The essential discovery had now been made; but it was to take a further 15 years for Fleming and his team to map the full extent of the system.

On that first day, in mounting excitement, Fleming and friend located no less than seven kilometres of Bronze Age wall running out across the moorland, intersecting and interrupted here and there by cairns (which turned out later often to have been used for burials). The full map finally produced shows a vigorous pattern of major divisions with parallel lines running back from them on all but the highest ground. Many of these now figure on the official Ordnance Survey map, described as "Boundary Works".

Inquiries on Dartmoor led, naturally, to the search for similar systems elsewhere. Reaves or their equivalent have now been found in Cornwall, both on the Penwith Peninsula and to the east of Bodmin. There are similar divisions in parts of the Peak District, in Teesdale, on the Cheviots (on the England/Scotland border) and on the Tabular Hills (which fringe the southern end of the North York Moors). The most exciting remains are in the Yorkshire Dales, especially in the Reeth area of Swaledale, where there are clear indications of a reave system on the high ground on either side of the valley.

There seems, then, little doubt that later Bronze Age society was organised on fairly large-scale principles, with power more probably flowing down than up. This seems to confirm suggestions from the lowlands that society in the Bronze Age was more authoritarian than in the Neolithic period, and more inclined to military solutions.

The uplands themselves were by now, except for the odd wood or coppice, almost entirely open ground. The result appears to have been disastrous.

How quickly people left the moors is a matter of dispute, but leave they did, and in large numbers, sometime round about 1200 BC. It is possible they departed because of some unknown political or military upheaval in the lowlands, making it possible for them to move down from the hills into the valleys. Perhaps they were simply thrown off the land, as was to happen to Scottish crofters during the eighteenth-century highland clearances. But it is far more likely that conditions had simply become too difficult on the uplands. A series of bad harvests combined with a small but critical drop in the temperature could have done it. Advocates of the sudden crop-failure theory point to 1159 BC and the shattering eruption of Hekla, a volcano off the coast of Iceland. Resulting clouds may well have blocked off sunlight and increased rain-promoted peat formation.

On balance, even accepting the likelihood of damage from Hekla, it seems most probable that the upland farmers of the Bronze Age left gradually, over an extended period, yielding up their land to blanket peatbog and simply following the nutrients in the soil downhill. Not that everybody went. In the Iron Age, people once more ventured on the moors

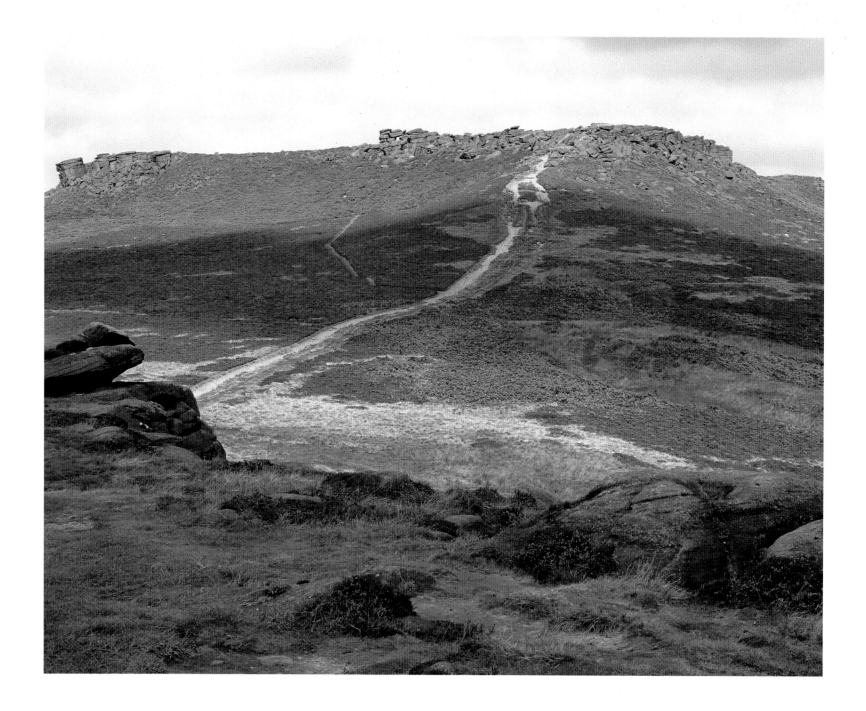

and built the enormous earthworks that we describe as forts — at Countisbury Hill in Exmoor, where the main road cuts up from the coast at Lynmouth right through the series of earthen ramparts; on the summit of Ingleborough, highest high point in the Yorkshire Dales; on Mam Tor in Derbyshire, where 15 acres are enclosed by earthworks; and, most spectacularly of all, just a few miles away from Mam Tor, at the site known as Karl Wark on the eastern side of the moors. Here a rocky peninsula sticking out over the valley has been walled off on the landward end with megalithic blocks of gritstone, hugely impressive, hugely suggestive.

But suggestive of exactly what? Many sites lacked water. Some were too big for practical defence. Most were on spots that would have been intolerable in winter. Is it possible that they were occupied only seasonally or on special occasions and that they were actually ritual centres where people met in time of stress or turmoil to reassert the unity of the community? The Wembley Stadium of each area, perhaps, ideal for sport, for song, for oratory?

We may never know. We only know the Romans came and took supreme authority to themselves. They used the moors as little more than obstacles that had to be surpassed. The Yorkshire Dales, as that Yorkshire luminary John Raistrick pointed out, are more than half boxed in by Roman routes. There is little more on top than a single road that leads across diagonally to the one-time Roman camp at Bainbridge. In Derbyshire, by contrast, a road sails up and across the southern heights, leading to Buxton with its warm mineral waters. Here the Romans certainly used the spa. Somewhere, though the site remains unknown, they had a smelting house for turning out lead ingots. They also mined at Alston in Northumberland, again for lead, a mineral which was to prove of vast importance later on.

But this apart, the Romans found little of value in the moors. The Bronze Age and Iron Age inheritance lived on, undisturbed for centuries, while peat accumulated, hawks and wild ponies held sway, and human beings, mostly, passed their lives elsewhere.

OPPOSITE PAGE:
The rocky outline of Karl Wark, the formidable Iron Age fort on Hathersage Moor in the Peak District.

THE MOORS IN HISTORY

THE MOORS OF ENGLAND, DESPITE THEIR OBVIOUS DISCOMFORTS, HAVE FEATURED IN MANY contexts in the country's history. One way to start is with the famous names, not least King Alfred, who leaps into the schoolbooks in the winter of AD 878.

Those versed in the tales of the Anglo-Saxons will remember that the Vikings — more often today referred to as the Danes — began to attack the English coasts in the late eighth century. They came "like stinging hornets", wrote Simon of Durham, attacking the Holy Island of Lindisfarne on the Northumberland coast in 793. By the latter part of the ninth century, the Danes were swarming through the north while Alfred, the young Saxon king of Wessex, struggled desperately to keep them out of the south-west.

Not desperately enough, however, for Alfred was caught off guard when the Danes, under their formidable leader Guthrum, made a surprise winter march against him, arriving while Christmas festivities were in progress. Bruised, battered and routed, Alfred escaped with probably no more than his own bodyguard. This small group slunk and fought through fen and forest to a hiding place in the Somerset Levels, on the low island-mound of Athelney, so deep in the marshes that only those with local knowledge could find their way there through the reeds.

Alfred held on at Athelney with great difficulties through the rest of the winter of 878, raiding for food like any guerrilla fighter. Somehow, he managed to convoke the fighting men of Somerset, Wiltshire and West Hampshire, meeting them at "Egbert's Stone", a place not yet identified. Two days later, in a battle critical to English history, he defeated Guthrum. Peace was agreed at Aller, close to Athelney, and a treaty made on the Isle of Wedmore, also in the Levels. By this, the Danes were acknowledged as the masters in what became the Danelaw, that part of England north of a line from London to Chester, while the rest of the

OPPOSITE PAGE:
A winter's day on Westerdale Moor, North York Moors.

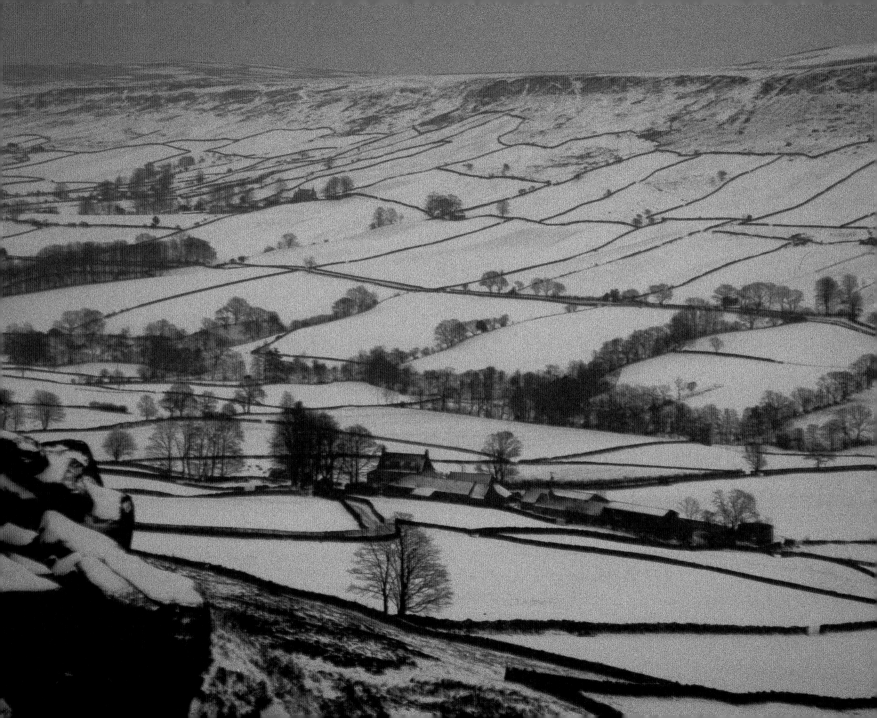

country was to remain free of them. Guthrum converted to Christianity, Alfred stood as his godfather and both sides combined in a tremendous 12-day party.

Few other moorland stories have so neat a climax. We know, however, that soon after the Norman invasion in 1066, William the Conqueror ravaged the North of England, with the result that large areas are described in the Domesday Book as waste or "wasta". This is the episode normally referred to as the Harrying of the North. After this, with Norman Lords settled in the Pennine valleys — and almost everywhere that offered prospect of good living — a new aristocracy emerged, with Yorkshire and its moorland landlords in the forefront.

Moorland history now naturally includes the record of these great families. One such was that of the Scropes, of Bolton Castle in Wensleydale, Yorkshire. This clan produced a plethora of royal chancellors and treasurers and featured large in the Wars of the Roses — with several Scropes beheaded for their pains — so earning them a place in Shakespeare's history plays. Nor was it surprising in a dynastic land that the Scropes married into that exceptionally grand family, the Nevilles, owners of Middleham Castle, close by on the eastern flank of the Dales. In Middleham the young Duke of Gloucester, the future Richard III, received his education and fell in love with the daughter of the house, Anne Neville. After their marriage, they made their home in Middleham from 1472 to 1483, lord and lady of the moorland and of its lower valley land.

Richard III, as will be well remembered, lost his crown on Bosworth Field and so, in 1485, the Tudor period began. As for the moors, Henry VII, the first of the Tudor monarchs, was in short order to face two separate rebellions, both featuring Bodmin Moor. The first Cornish rebellion was led by the Bodmin lawyer Thomas Flamank, in protest at taxation for the Scottish wars. After assembling at the town of Bodmin and marching across Bodmin Moor — hard to avoid in any Cornish rising — he and his men got as far as London before being cut to ribbons at Blackheath. The leaders were executed; the survivors drifted back to Cornwall. Yet only three months later, Perkin Warbeck raised his standard in Bodmin, posturing as one of the two princes whom we now know to have been

murdered in the Tower of London. Warbeck gathered a substantial force but on this occasion, the Cornishmen got no further than Somerset before they were defeated.

From a moorland perspective, the real point of the Cornish rebellions is this: there was simply nowhere so apt to nurture independence and rebellion as inaccessible, wild country in far-off corners of the kingdom. More episodes of the same kind were to be expected and they duly came. Perhaps the most spectacular was that of the Duke of Monmouth in 1685, which ended disastrously at the battle of Sedgemoor, once again in the wetland moors of the Somerset Levels. The story, in outline, is this. In 1685, King James II, a Catholic, succeeded his Protestant brother Charles II. Anti-Catholic uproar ensued. In the midst of this, the young Duke of Monmouth, the dead king's illegitimate son, rose in the Protestant cause against his uncle James II. He had few men at his disposal but believed he would find supporters as soon

LEFT:
River Fowey on Bodmin Moor.

as he took the field. Accordingly, he sailed from Holland to the south coast of England in the summer of 1685, landing at Lyme Regis. Trailing his way inland, he did indeed pick up some 7,000 men. But slowly these forces dwindled away, and he had only about 3,500, mostly badly armed peasants, when he was finally cornered by the king's forces on July 5 at Bridgwater in Somerset.

Deciding to fight his way out, Monmouth advanced late that night, under cover of darkness and in deep silence. His route took him into the Levels. Here his army lost its way and a rash pistol shot lost them the element of surprise. As day dawned over Sedgemoor on July 6, the royal guns and cavalry overwhelmed the strange little army of insurgents.

Monmouth himself fled, though he was later caught. His followers were slaughtered on the Levels or herded as prisoners into nearby Westonzoyland Church. The battlefield today seems eerily tranquil, with green banks hiding brimming drainage ditches and swans standing on the distant meadows in what appears a conversational gathering. Behind the battlefield lies the village of Westonzoyland. Within its church, the roof beams are adorned with angels, with extra angels ranged along the sides, all with wings widespread. Some of the prisoners were hanged from the trees in the churchyard. Conditions in the church itself were extremely harsh. But one man at least was on the side of the prisoners; Richard Alford, church warden, bribed the guards to let him in with water and provisions. His memorial stone may still be found inset in the church floor.

Unlike the Duke of Monmouth, Sir Francis Drake was a proper moorland man, from Tavistock on the edge of Dartmoor. He received £300 from Queen Elizabeth to construct a leat or small canal to carry drinking water from Sheepstor on the moor all the way to Plymouth. He made his home at Buckland, a former abbey already spectacularly converted to a private house. Today it is hardly five minutes by car from the moor's edge.

Then there was Sir Walter Raleigh, Drake's contemporary, who became Lord Warden of the Stannaries — that is to say, the lord of the tin-mines of Cornwall and Dartmoor. Meetings and assemblies were often held out on the open moor. In our own day, the Duke of

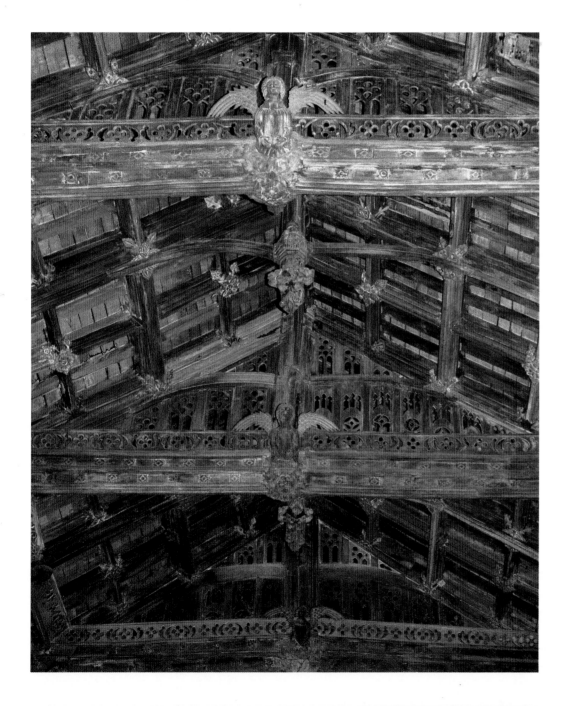

LEFT:
Angels spread their wings under the great beamed roof of Westonzoyland Church in the Somerset Levels.

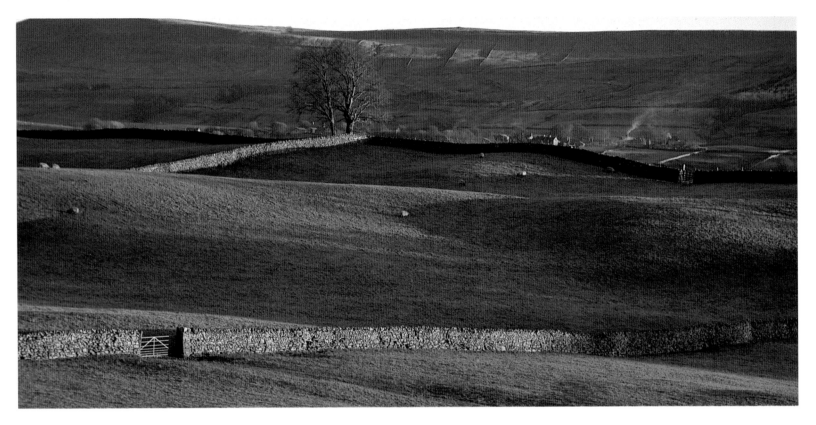

ABOVE:
An evening scene below Hawes, Wensleydale, in the Yorkshire Dales.

OPPOSITE PAGE:
The small barns on Stonesdale Moor, Yorkshire Dales, traditionally hold hay for the winter feeding of stock.

Cornwall is none other than Prince Charles, long-term heir to the British throne. He happens to own almost all of Dartmoor.

BUT IF FAMOUS PEOPLE AND MOMENTOUS HAPPENINGS GIVE POINTS OF REFERENCE AND PERHAPS suggest places to visit, they cannot offer a sense of the flow of daily life and its impact on the landscape. For this we have to take a slower, even more local look; and here, the Yorkshire Dales make a convenient starting point, having experienced every wave of immigration in the formative centuries after the Romans left. The resulting pattern of human settlement is still reflected in the towns and villages of the Dales and often seems, despite the obvious contradiction, the very quintessence of Englishness.

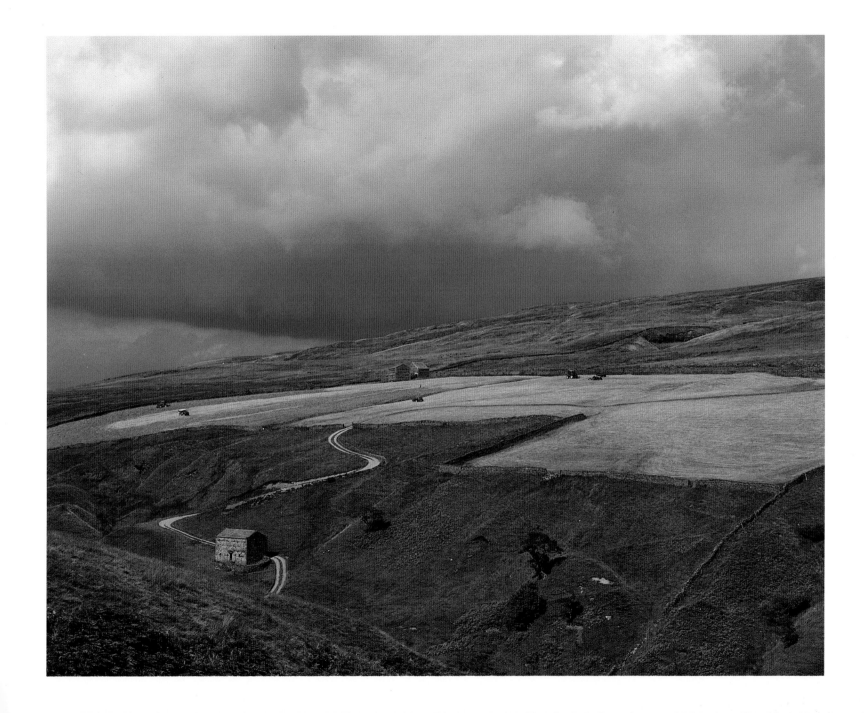

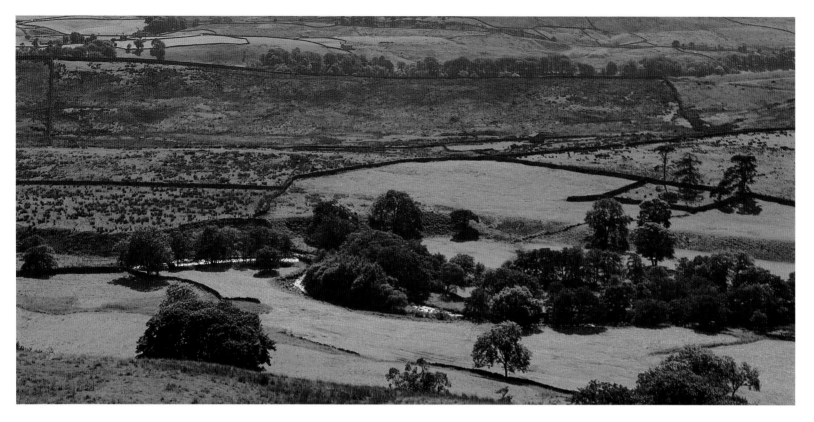

Farmland, Wensleydale, Yorkshire Dales.

The story starts with the Celts. They were left in occupation of the Dales when the Romans departed. Next came the Angles, pushing the Celts westwards towards their ultimate retreat in Wales and Ireland, the Scottish Isles and Cornwall. The Angles were migrating from the east, so naturally they settled first in the eastern valleys of the Dales. The names of their communities often ended in the suffix "ley", which meant a village in a woodland clearing — Ilkley and Shipley, for example. Up on the higher pasturelands of the limestone country, and in the nearby valleys, the most common name ending was "ton", our modern "town" as in Grassington and Skipton.

The Danes, of Lindisfarne and Wessex fame, soon followed, also arriving from the east. They seem to have taken over existing villages, then settled in the next-best sites as well.

You can recognise Danish "foundations" in names that end with "by" and "thorpe"; there are many of them, as a glance at the map will show.

From these layers of settlement, we today receive the layout of many of the oldest villages in the Yorkshire Dales. Some are tight little valley settlements. Others are centred still on village greens. Both, in their different ways, are intensely beautiful.

The next great wave was that of the Norsemen — people who came from tribal groupings in the land now known as Norway. They arrived in the Yorkshire Dales in the tenth century, coming, rather surprisingly, from the west, from earlier Norse settlements in Ireland. They moved peacefully on to the unoccupied, higher ground of the Yorkshire Dales, using it mainly for stock-rearing and shepherding.

The Norsemen lived not in villages but in isolated, self-sufficient farmsteads. These generally had still higher summer pastures with a separate shelter or dwelling for summer

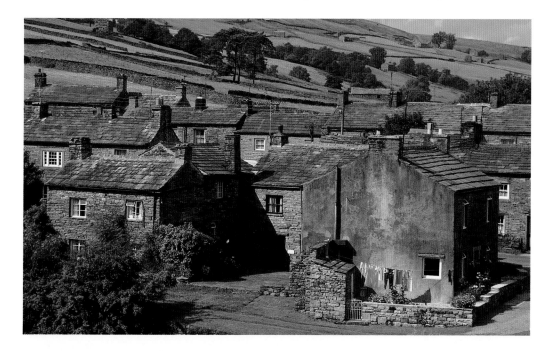

LEFT:
Houses huddle for protection in Thwaite, Swaledale, in the Yorkshire Dales.

shepherding. Though the original Norse buildings have been replaced by later farmsteads, many of which are themselves now in ruins, the sites are instantaneously recognisable — wild, remote, romantic to an eye that does not spot the potential for winter hardship. You will see some of their lower sites as you drop down Deepdale Hill, through a shovel-shaped scoop of valley, into once-isolated but ever-lovely Dentdale. It is a thrilling approach, thanks not least to the still visible legacy of the Norsemen. Nor is it a surprise to find that the Norsemen have also given us a goodly number of name endings, from "thwaite", a clearing or a sloping field, to "sett", from "saetr", a Norse summer-dwelling, found still in such names as Appersett.

Into this evolving brew, the Normans arrived decisively from 1066, permeating not just the Pennines but the whole of England. Their splendid castles and glorious religious houses, revised, amended, sometimes totally reconstructed in succeeding centuries, and with fresh castles and monasteries added in the later Middle Ages, are the first surviving buildings in moorland areas. The only exceptions are a bare handful of Anglo-Saxon churches and Norman bits and pieces in generally later parish churches.

THE CASTLES GOT OFF TO A SPECIALLY QUICK START. IN THE YORKSHIRE DALES, RICHMOND, AT the mouth of Swaledale, was begun by William the Conqueror's own cousin. Skipton (only a gateway remains of the Norman buildings) and Middleham (twelfth-century keep and thirteenth-century walls) were both founded early. Wensleydale's Bolton Castle, on the other hand, with its three imposing towers (the fourth fell down), was a tardy arrival, not built till the fourteenth century.

The system of control by castles, seen so clearly in the Yorkshire Dales, was used on other valley-and-upland tracts. In the North York Moors the southern approaches were controlled by fine castles at Helmsley and Pickering. In the Peak District, the castle of Peveril, perched above Castleton, was powerful in its day and survives into ours with a dash of medieval romance. Bodmin had the mighty castle of Launceston on its eastern flank, while, in

the Dartmoor region, Okehampton Castle lay to the north of the moor and the castle of Lydford immediately to the west. This last, though simply a tower on a mound with cellars deep inside, is in some ways the most interesting of all. For it was central to the Norman use of Dartmoor as a royal hunting ground.

The Norman ruling classes were passionate huntsmen. Soon after their arrival, enormous tracts of the moors were simply closed off from ordinary use and dedicated, under the slightly confusing name of "forest", entirely to hunting. "Forest" meant a wild, unenclosed tract of countryside where deer and other game could live undisturbed. All the central area of Dartmoor was declared a forest, as were great portions of the Dales and the Peak District. The main purpose of Lydford Castle was to act as a prison for those who had broken the laws of the royal forest of Dartmoor.

The forest laws were ferociously enforced. Death was a common punishment for an infringement, with mutilation and imprisonment the soft option. Lydford soon won a reputation for imposing these punishments with reckless disregard of truth. William Browne, in his *Britannia's Pastorals* of the early seventeenth century, opens his passage on Lydford merrily enough but soon realises a sombre approach is more appropriate:

> I oft have heard of Lydford Law
> How in the morn they hang and draw
> And sit in judgment after.
> At first I wondered at it much
> But soon I found the matter such
> As it deserves no laughter.

NORMAN MILITARISM AND THE SAVAGERY OF FOREST LAW FORMED A BACKGROUND FOR THE development of monasteries. These were to prove immensely important to the moorlands.

There had been earlier monasteries, essentially Celtic, and some of these survived into

the Norman era. Most had been established in wilderness sites by early preachers returning from Ireland after a gap of many generations. Bodmin Moor is studded with churches and chapels dedicated to these Celtic saints. St Piran was an Irish saint who lived, says the story, for 200 years after reaching Cornwall; he became patron of the tin-miners. St Nonna had an altar, in a site still specially venerated, whence the place-name Altarnon. St Neot's church retains particularly beautiful stained glass from the fifteenth and sixteenth centuries.

By far the most important of the early monasteries was at Glastonbury in the Somerset Levels, founded in Celtic times. Some stories claim that St Patrick, the patron saint of Ireland, came as a visitor, even that he is buried there. It was natural for the Normans to take it over and it progressed to become an even more substantial power in the land.

Meanwhile, during the earliest Christian era, the abbey of Whitby at the far end of the country had been almost equally important. It stands above the River Esk, with a wonderful backdrop, part moorland, part North Sea. It was here that the first abbess, St Hilda, gave shelter to the herdsman Caedmon, the first of the English poets, who received the gift of composition in a dream. Later, Whitby was the site of the famous Synod, or ecclesiastical assembly, where the individualistic Celtic church was reconciled with Rome. But the abbey was soon razed by Danish raiding parties and lay in ruins until the arrival of the Normans.

When it was re-established, in 1078, it became one of the first of the Norman religious houses. The man responsible was a monk named Reinfrid, who had probably served as a knight under William the Conqueror. Making a dangerous journey from southern England, he was shocked by the desolation he found after the Harrying of the North. This seems to have been a major motivation in his undertaking at Whitby. The soaring, empty windows still standing today date mainly from the thirteenth century. The church was damaged in Henry VIII's Dissolution of the Monasteries in the sixteenth century and again by shells from a German battle-cruiser during World War One. But in all their elegant simplicity, the ruins still appear a profound expression of monastic spirituality.

The other great monastery of the North York Moors is Rievaulx, set deep in the

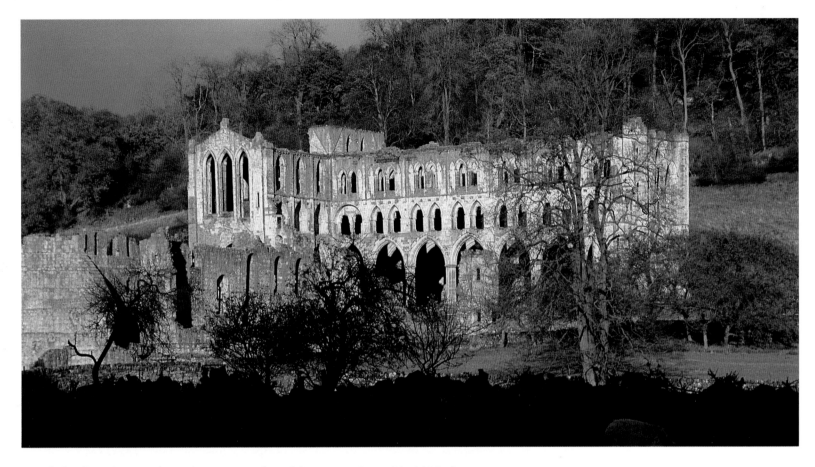

ABOVE:
Rievaulx Abbey, Rye Dale, North York Moors.

wooded valley of Rye Dale on the western edge of the moors. Started in 1132, the great age of monastery foundation, this was the earliest of Yorkshire's Cistercian monasteries. It soon became the centre of a vast, virtually self-sufficient estate, producing more wealth than could easily be consumed on the premises. This obviously represented a conflict with any notion of monastic austerity. Within a mere 50 years of its foundation, Rievaulx had 140 monks, 240 lay brothers and 260 hired workmen. The monastery obtained land for horse-breeding on the Tees, for cereals in the Vale of Pickering and for ironworking in the Barnsley–Wakefield area. The monks had no fewer than 16,000 sheep, running many of them in the Yorkshire Wolds,

RIGHT:
The ruins of Bolton Priory, Wharfedale, in the Yorkshire Dales, are irresistible to photographers.

OPPOSITE PAGE:
Church window, Trentishoe, Exmoor.

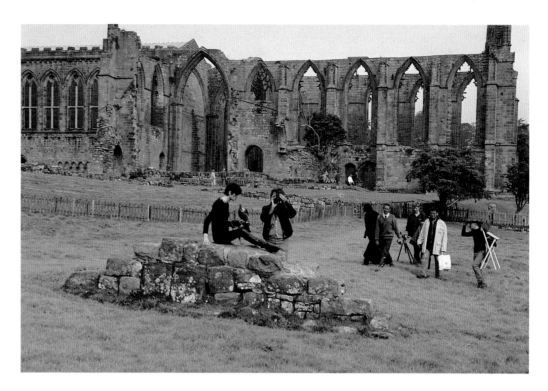

with more on the North York Moors. In its day, Rievaulx dominated local life and had a huge impact on all the stretches of the moorland that the monastery used.

Fountains Abbey, further south in Yorkshire, was founded as a breakaway Benedictine house in the same year, 1132, but passed into the hands of the Cistercians in 1135. The Fountains estate included, among other lands, rich pasturage on the limestone grazing-grounds of Malham in the Yorkshire Dales. This was shared with Bolton Priory, a religious house in Wharfedale, right in the heart of the Dales, a place so beautiful and so well documented that it is worth pausing for a moment to examine it as a representative example of monastic life.

Harmonious and serene, Bolton is set among gently tilting fields beside the River Wharfe, with moorland rising almost immediately above. Following the Dissolution of the Monasteries, the church and much of the estate came into the family of the Dukes of Devonshire, with the result that many of the records of the monastery have survived at

Chatsworth, the magnificent Peak District residence of the Devonshires. In terms of monastery and moor, the most interesting of the Chatsworth–Bolton documents are the accounts covering the years from 1286 to 1325.

From these we learn that an establishment of only 19 monks possessed no fewer than 13 sheep farms. In 1310–11, their best year, they had a total of 3,578 head of sheep, kept more for wool than for meat. This was the key to the wealth of the medieval monasteries and, at that time, of England as a whole. In the monasteries in particular, wool production was supported by careful breeding and shepherding and led to such landscape features, still easily seen today, as moorland droveways, broad enough for the animals to graze as they moved along. One of the loveliest of these is Mastiles Lane, leading from the Malham estates of Fountains Abbey down to Kilnsey on the River Wharfe. But much of the Dales moorland is criss-crossed with the monks' "green roads".

Because the monks were meant to be at home in their cloisters praying, the day-to-day farming at Bolton, as elsewhere, was mostly handled by lay-brothers. The outlying farms were known as "granges", a name still common on the moors for larger houses and farms. Most of the roads ran from grange to grange or between grange and mother foundation.

Back in the priory, as we learn from the Bolton accounts, the profits of the sheep were dedicated to particular "departments". The Cellarer was effectively general manager, and, under him, the Refectorer supplied the food. For this he had his own flock of sheep. But so too did the Sacrist, who was responsible for the upkeep of the church. The priory also had to pay its labour force — 200 lay-brothers and workers at Bolton itself and a further 101 outside the precincts. This was a huge community, considering the small numbers in the local population. If the workers' families are added, the total was probably close to 2,000, all dependent on the priory farms and sheep.

Historians find another rich source in the letters of congratulation or rebuke that followed official inspections — known as Visitations. These were carried out by the local archbishop or bishop. One of the Bolton Visitation letters, written in 1280, stresses that the

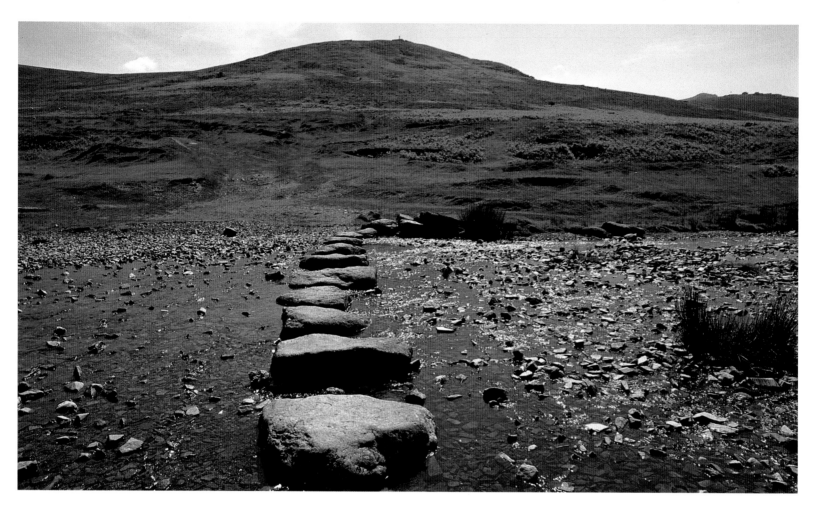

Stepping stones across the River Lyd, on Dartmoor, point the way to Widgery Cross on the summit of Brat Tor.

canons should stay within the cloister "unless unavoidable necessity shall require such entry or egress without harm". But this was obviously more easily written than achieved, since the letter went on to observe that any individual who disobeyed "shall be content with bread and water on the morrow and shall incur other punishment as the sauciness of a rebellious person shall require. Moreover, we utterly forbid from this hour any roaming whatsoever about the moors and woods for any reason whatsoever". Poaching, the documents make clear, was one

pursuit that sometimes drew the canons forth in defiance of regulations.

Henry VIII's decision to abolish the monasteries was partly a matter of humbling the overmighty, and partly a matter of seizing their wealth and redistributing it to the country gentry, thus binding them to him. It was also, though in a lesser way, a matter of religion. The smaller monasteries went first, accused of more irregularities than was probably the case. In the conservative north, the assault on the monasteries led to the Pilgrimage of Grace, the Yorkshire-based and Yorkshire-led rebellion that for a moment in the autumn of 1536 seemed likely to threaten not only Thomas Cromwell, the responsible minister, but even the throne itself. The rising faded away, however, after the crown pretended to agree to the conditions of the rebels. As soon as it was safe to do so, the leaders were executed, along with the abbots of Jervaulx, Kirkstead and Whalley and the ex-abbot of Fountains. These executions formed the prelude to an attack on the bigger monasteries, accompanied by the executions of yet more abbots. For the moors of England, it was the end of a four-century-long domination by the religious houses.

Much, however, remains, from the ruins themselves to the monks' droveways and their horse-and-footroads, known as "trods". (Do not be deceived, however. The so-called Abbot's Way from Buckfast to Tavistock is an eighteenth-century invention.) Here and there an abbey has even been revived. Buckfast, on the southern side of Dartmoor, was totally rebuilt at the start of this century by a tiny group of monks working for years as labourers and stone-masons. At Blanchland, on the Northumberland–Durham border, the abbot's guest house has survived and is now an intriguing hotel, the Lord Crewe Arms, named after a subsequent owner. In practical terms, however, the monasteries were done for by the end of 1539.

NOT THAT RELIGION LEFT ORDINARY FOLK UNMOVED. FROM THE EARLY MIDDLE AGES TO THE eighteenth century, numerous crosses were erected on the moors, a few as memorials, others to show the way. In many places, being in the same local stone, they add considerably to the atmosphere created by prehistoric monuments.

Clapper bridges, too, were probably built during the early Middle Ages. These

wonderful, and typically moorland, structures consist of a bridge of huge stone slabs balanced on dry-stone pillars standing in the water. Dartmoor has many of them, some ruined, some in good condition. The best of all is the so-called Tarr Steps, a 55-metre-long bridge across the River Barle on Exmoor, with 17 pairs of parallel slabs extending from one pier to the next, in a deep valley of delicate woodland beauty.

The oldest surviving dwellings are probably from about the same period as the clapper bridges. These are the famous longhouses, built almost always of local stone. The typical longhouse is a lengthy structure, only one room deep, with the living quarters at one end and space for animals and their fodder at the other. The animals' quarters are called the "shippon", and are usually a little lower than the human habitation. House and shippon were often divided by a through-corridor, with a door at either end. If both doors were opened and a wind was blowing through, the corridor could be used for winnowing.

Surviving longhouses are few and far between. Nor, up in the moorlands, was there any other kind of medieval building, aside from military or ecclesiastical, strong enough to last the course. This situation changed with the seventeenth century, when the new wealth available to local people, partly through the Dissolution of the Monasteries, encouraged the better-off to put up new and well-constructed buildings in the valley villages.

The new houses occupied the sites that had been established so many centuries ago by Danes and Angles. The result was certainly a great number of delightful individual homes. Even more satisfying were the ensuing architectural groupings, with all the houses down a single street, or round a particular village green, built in a "family" style by traditional craftsmen. Mullion windows are almost a trademark in the north of England. Thatch, once prevalent, is now relatively rare in the North Country. Thatched buildings do remain more common on the West Country moors, and specially in the valleys and small towns around the edge of Dartmoor.

The towns are another key part of the moorland pattern and here there are real similarities from Land's End to the Scottish border. The key point is that the customary physical structure of the moors, with high ground pierced on several sides by valleys, means in effect that

LEFT:
*Many of the towns and villages around
Dartmoor breathe the same sense of peace. This
colour-washed cottage and churchyard are at
Drewsteignton, Dartmoor National Park.*

none of the moors has any single, natural capital. All, however, have market towns higher or
lower in the valleys. Many of these started in the early Middle Ages by offering provisions to
the military communities associated with the castles. Later the towns became trading and
wool-dealing centres for their own agricultural districts, while also supplying the monasteries
with goods they could not produce themselves. Many of these came from overseas. Bolton
Priory bought in almonds, raisins, figs and wine, the latter in surprising quantities.

The towns were more adventurous than the villages in introducing new architectural
styles, so that by the eighteenth century we find a growing number of fairly formal, classical
houses. Some grander country houses were built in the same style and little by little a hum-
bler version crept into the farms and villages, meaning that the later moorland building styles,
from yeomen's farm to the larger dwellings of the market town, share much of the richness of

the Georgian period. This, rather surprisingly, is one of the abiding delights of the moors.

Stylistically speaking, the churches are more limited. Perhaps the dominance of the monasteries diverted energy away from parish churches during the Norman period; and many of those that were built have disappeared as a result of later reconstruction. As is only logical, a number of churches have survived from Gothic times. If one had to name a characteristic style it would be the Perpendicular, the final burst of Gothic, fashionable from about 1400 to 1550, with windows occupying most of the wall space and, rising over all, a set of knobbly pinnacles at the top of a tall tower.

Much-visited Widecombe, home of Widecombe Fair on Dartmoor, is a good example. Through the high church windows you can look straight out over the valley and up on to the moor, with its Bronze Age stone circles. There is a glorious set of painted bosses in the church roof. One represents the Green Man of rural legend. Another is a triangle composed of the ears of three rabbits running in a circle. Representing the Trinity, this was a symbol of the Dartmoor tinmen, who got much of their nourishment from rabbits. The rabbits were reared on the moor in artificial, cigar-shaped warrens known as "buries" or "pillow-mounds".

Lydford, diagonally across the moor to the north-west, also has an extremely interesting church. Dedicated to the Celtic St Petroc, it originally served the whole of the moor and royal forest. As a result, the bodies of the dead had to be brought for burial from a long distance. A Lych Way, or Corpse Road, was developed right across the moor, still easily followed by walkers. But in winter this was extremely difficult for funeral processions. In 1260, when the local bishop heard that the distance to Lydford was "eight miles in fine weather and 15 in time of storm", he gave permission for the deceased on the eastern side of the moor to be buried at Widecombe.

You can, of course, find individual churches of most periods, and though the range may not be quite so compelling as in more deeply settled lowland areas, exploration yields real gems, from the great church at Tideswell, so-called cathedral of the Peak District, to the tiny but intricate parish church of Blisland on the western side of Bodmin. Tideswell's is in

the Decorated style of the fourteenth century (though with a Perpendicular tower), that of Blisland largely in Early English, eloquently restored in the nineteenth century. At Pickering in the North York Moors, the church possesses one of the fullest sets of medieval wall-painting in Britain; in the church by Easby Abbey in the Yorkshire Dales, you will find what may well be the most beautiful of all such paintings in Britain, reaching from Adam and Eve to the life of Christ, with a woman spinning, as so many did in those parts, and a man leaning on his spade, a cross at the top of the handle.

Nor is it a surprise to find in Cornwall, and other districts where there was a hard-pressed working population, that nonconformist chapels sprang up in competition with the churches. From the late eighteenth century, when John Wesley made innumerable trips to

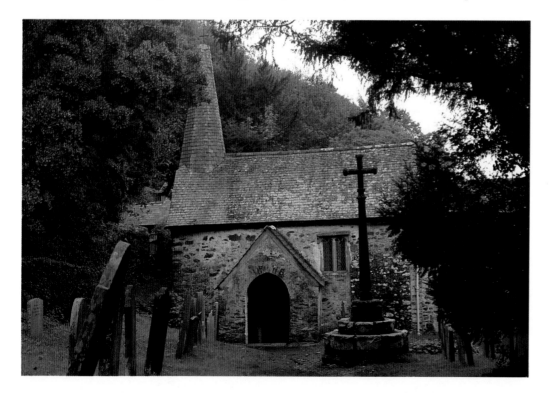

OPPOSITE PAGE:
The church beside the ruins of Easby Abbey, Swaledale, in the Yorkshire Dales, contains a vivid set of murals. Pictured in this one is a sower in springtime.

LEFT:
Exmoor's St Culborne Church, built between the twelfth and thirteenth centuries, is hidden in woods close to the sea.

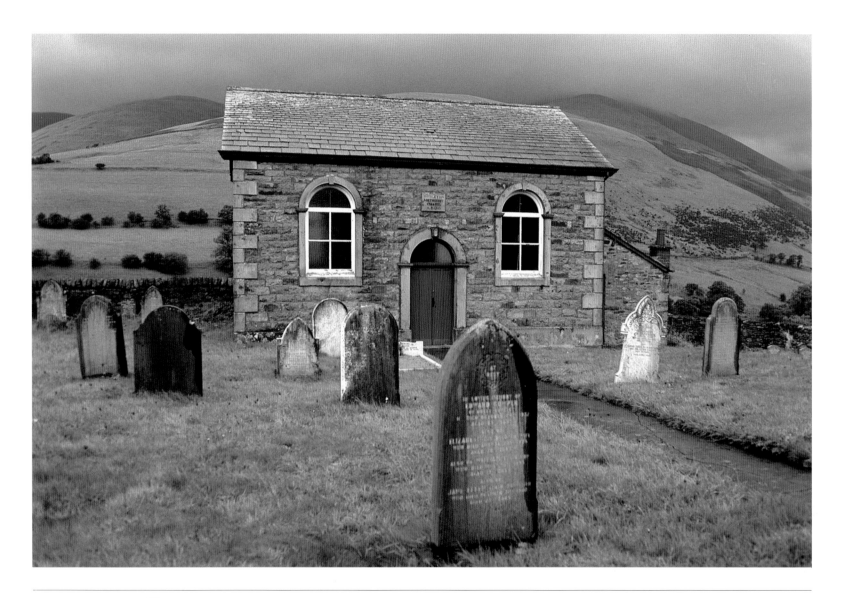

Cornwall and almost as many north into the Pennines, Methodism particularly held sway. Many of the chapels have now disappeared, but there were so many that even the survivors form a notable aspect of the moorland landscape, small, most often grey and infinitely serious in aspect.

THE MOORS WERE WILD IN THE EARLY DAYS. BOLTON PRIORY EVEN EMPLOYED "WOLF-SLAYERS". LITTLE by little the uplands were tamed, to some degree, by monastic sheep farming. The last wolf in England was killed near Pickering; the last wild boar, so it is claimed, met an untimely death at the spot now called Wildboarclough, a valley in the Peak District. Industry played a part as well, rising from small beginnings to a real frenzy by the eighteenth and nineteenth centuries.

LEFT:
"Wayward" women were once buried at cross-roads to stop their spirits from finding the way home. Flowers appear daily on poor Jay's grave on Dartmoor, north of Hound Tor.

OPPOSITE PAGE:
Brant Fell, near Cautley in the north-east corner of the Yorkshire Dales National Park, rises behind this moorland chapel.

Cornish tin comes first, having had a reputation in the ancient world of the Mediterranean. In fact, there is little if any evidence of Bronze Age tin-mining in Cornwall, possibly because any workings were swallowed up by later ones. Tin-mining was certainly important by the start of the thirteenth century when King John gave the tin-miners or "stannars" a charter of their own. This allowed them a great degree of independence under their own elected Warden of the Stannaries. The blocks, or ingots, won by smelting the tin ore on both Bodmin and Dartmoor had to be taken down to the half-dozen Stannary towns at the foot of the hills. Here the tin was tested for quality by clipping a coign or corner off the edge (whence our later word coinage), then stamped — and heavily taxed — if it was up to standard.

The medieval miners worked mainly to win alluvial tin from water-courses, redirecting streams to scour the ore out of the earth. These artificial rivers were called "leats". The extent of the workings is astonishing in some places, specially on Dartmoor, leaving a characteristic ripple of rubble beneath a covering of heather and bracken on valleysides. Where streams enter wider valleys there are often large piles of detritus, grown over with vegetation. Later the miners drove horizontally into hillsides and by the eighteenth century were digging vertical shafts into the ground. These were hollowed out below, producing the characteristic mines called "bellpits".

Lead and arsenic were also mined on Dartmoor. In the 1830s copper was discovered, in great quantities, at Caradon on Bodmin and a copper rush began. Thirty mines were soon at work. But it was an occupation of terrible danger, with collapsing roofs in shafts and long, long ladders from which an intolerable number fell to crippling injuries or death. While the copper boom was at its height, the average age of those buried in the parish church of St Cleer fell to a pitiful 21 years. The remains of the copper mines still crowd the landscape round the villages of Caradon and Minions and close to the Hurlers, those mysterious Bronze Age stone rings. The shafts are meant to be blocked off, though in all such areas one should be careful of any kind of hole that suddenly reveals itself. What remains, most poignantly, are the elegant, stilled chimneys and the empty, roofless engine houses, where steam powered the

OPPOSITE PAGE:
Wheal Betsy, the ruined engine house of a Dartmoor mine which once produced lead, copper, silver and arsenic.

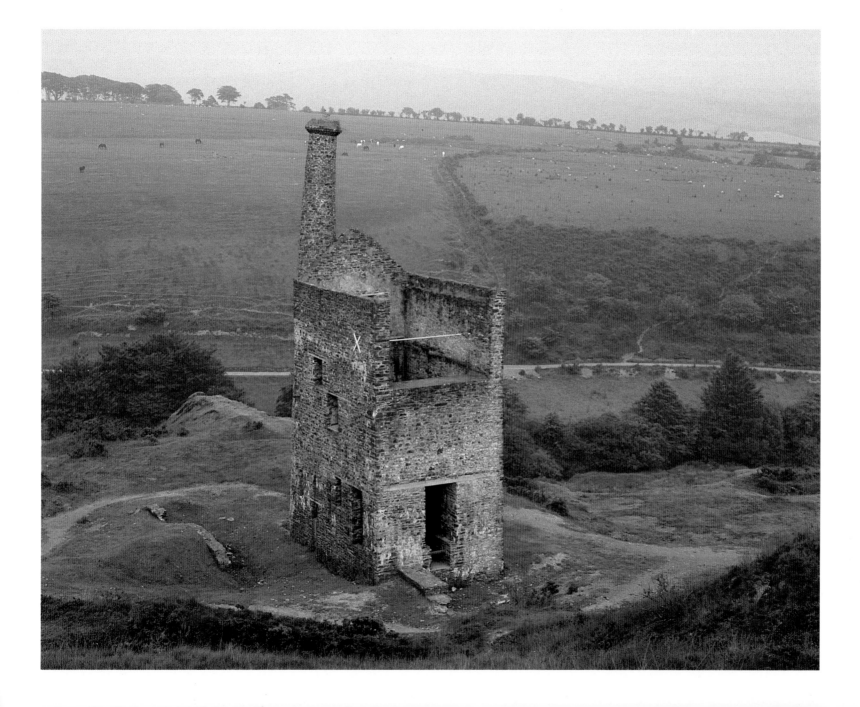

RIGHT:
A summer fair in Glossop on the heavily industrialized western edge of the Peak District.

machinery for pumping out the water that would otherwise have drowned the mines.

In the Peak District lead has been won since time immemorial. Ingots from the Roman period still survive. By the Middle Ages, the miners were scouring the hillsides with water as in the West Country moors and excavating the "scrins" and "rakes", those long, thin seams where the lead ore lay in the earth like a suspended ribbon. The workings can still be seen in many places, particularly on the limestone uplands, as long, thin channels in the earth, now grown over with grass, and flanked on either side by grassy banks of spoil.

Later on, bellpits became common here too — looking nowadays like circular depressions in the earth with circular banks of spoil around them, grass-grown as usual, the pits running in a line as they follow the seam of ore. In due course, underground "pipes" of ore were also mined, often causing underground flooding. Sir Cornelius Vermuyden, the

Dutchman who drained much of the Fen area of East Anglia, was brought in as an expert. By the end, there was a complex system of drainage tunnels, bored slightly upwards through the hillsides to drain the higher mine workings.

At the most intense period, in the eighteenth and nineteenth centuries, there were some 6,000 miners on the Peak District moors. Operations continued, diminishingly, into the twentieth century. The result is a landscape riddled with mine-workings — 30,000 of them, so it is said — and adorned, every now and then, by warning signs that show little figures falling, through tumbling rocks, down endless-looking mine-shafts. You certainly have to go carefully in the heavily worked areas, following path-signs and avoiding curious hollows in otherwise innocent-looking fields. In some places, like the Magpie Mine at Sheldon, not far from Bakewell, "Cornish"-style engine houses survive, and even winding gear, making the past seem close enough to touch.

Lead was also mined, though in a slightly smaller way, right up through the Yorkshire Dales. At Reeth, in Swaledale, many mine-workers' cottages survive, now often converted into second homes for town-dwellers, and in the tributary valleys of Arkengarthdale the extent of the earth-moving involved is again astonishing. Weardale in Durham is also full of lumps and bumps of overgrown spoil, with a lead-mining museum high in the valley at Killhope.

Coal too was mined in the Pennines where it came near the surface, as witness Alston, also well known for its lead, and Fountains Fell in the Yorkshire Dales. "Moor coal" was also found on the North York Moors. None of it was so extensive as in the latter-day deep mines of Nottingham or South Wales, but there was enough to be a valuable resource till cheaper coal came in by rail. The highest moorland mines must surely have been those on the desolate uplands of Tan Hill, north-east across open country from the head of Arkengarthdale. The mine was worked from 1296; nowadays it is the site of the highest year-round pub in England.

All the earlier forms of industry were brutally conducted and brutalising. Sir Walter Raleigh spoke of the Cornish tin-miners as "the roughest and most mutinous men in England", a view echoed by Sir Francis Drake. Two and a half centuries later, the journalist

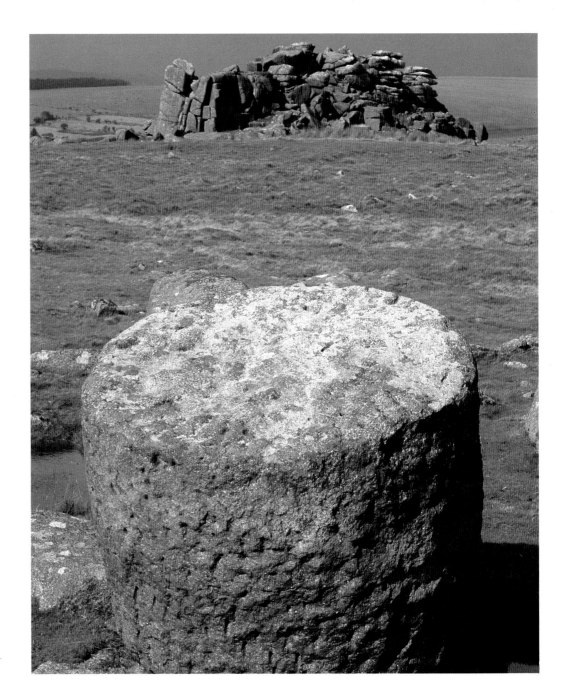

RIGHT:
A Dartmoor tor lies beyond a chunk of granite that was rough cut into a column for a public building, but never used.

Daniel Defoe described the inhabitants of the Peak District, and the lead-miners particularly, as being "of a strange, turbulent, quarrelsome temperament". Both groups were subjected to fierce local laws. In Derby the first two thefts of lead were punished by fine. On the third occasion, the offender's right hand was impaled with a knife or nail to the winding structure at the head of the mine-shaft.

The other great moorland business was quarrying, usually for building stone, and in Derbyshire, specially, for the millstones used in many thousands of British cornmills and by the knife- and blade-makers of Sheffield. Many millstones still lie, mournful and romantic-looking, just where they were left in the early part of this century when the technology changed and they were suddenly no longer needed.

Then there was limestone quarrying, often very small in scale, with individual farmers

ABOVE LEFT:
Quarry-workers' cottages near Sleight on the North York Moors still provide sturdy homes.

ABOVE RIGHT:
These millstones were abandoned next to a quarry near Upper Padley, in the Peak District, when the industry collapsed at the beginning of this century.

RIGHT:
This quarry on Bodmin Moor reveals the granite structure of the hills.

digging from limestone outcrops on their land, then burning down the limestone for fertiliser. Of these stone-built lime-kilns, there were many thousands, particularly on the White Peak of Derby and in the Craven highlands. Great numbers still survive as ruins. They look like stout little towers, square or round, with a circular hollow inside. Into this the lime was tipped from above onto a grate below. The fire at the base was fuelled, and the reduced lime removed, by way of a wide mouth at ground level, indication that this is a lime-kiln, not a mine-shaft capping or some other nameless structure.

The extent of the mining and quarrying meant that by the end of the seventeenth and start of the eighteenth century the moors were by no means as lonely and desolate as one at first imagines. There was also considerable movement of goods. The miners and other upland

LEFT:
A tidily built bridge adds to the beauty of the Goyt Valley, a popular spot for outings, near Buxton in the Peak District.

workers needed both to receive provisions and to send their products down to the valley towns. Cheese came up from Cheshire to pay for lead or travelled down from the Dove Valley in exchange for malt and corn. Salt made its way to every moorland farm and cottage.

The beast of burden that accomplished all this was the packhorse. It is estimated that 16,000 to 20,000 packhorse loads were carried along the ten miles of road between Grassington and Skipton in the Yorkshire Dales each year. Great numbers of trackways came into being, with special little bridges — narrow and low-walled so as not to bump the panniers — springing up at critical river crossings. These sweetly arched little structures were mostly built between 1660 and 1740 and remain an exceptionally beautiful element in the archaeology of transport.

At the same time as the packhorses, there was another flow, north to south, entirely different in character. This was the movement of vast numbers of Scottish cattle for the growing markets of London and the Midlands. They came along the drovers' roads under the charge of perhaps a single drover with a couple of boys and a dog. Wherever the drovers paused long enough to gather in a group, they made a wonderful, outlandish spectacle. The English poet John Clare was struck by their attire, as well as the dust that rose above the herds like "smoaking clouds". They were, he wrote with feeling:

oddly clad
In petticoats of banded plad
Wi blankets oer their shoulders slung
To camp at night the fields among.

But even after their long march they still retained

honest faces fresh and free
That breath of mountain liberty.

This man-made leat, or water channel, one of the many on Dartmoor, is a reminder of the importance of mining on the moor.

INTO THE MOORLAND MIX OF MOVEMENT AND MANUAL LABOUR, THERE NOW ERUPTED THE VAST changes we commonly refer to as the Industrial Revolution. The given starting point was a rainy, water-loaded upland with plenty of wool available and much skilled labour developed in cottage industry — the carders, spinners and garment knitters of the moorland valleys. All that was required was the development of machinery to take advantage of the water power. From Arkwright's water frame onwards, the inventions came thick and fast in the latter part of the eighteenth century. Imported cotton was soon added to local wool as a raw material. The early capitalists built strong, severe-looking factories, known as mills, to process the wool and cotton. These naturally followed the line of water-courses, creating medium-sized milltowns in the valleys — Holmfirth and Hebden Bridge are two examples — and provoking enormous growth in the cities round the edges, from Manchester to Halifax and Bradford.

The mills flourished for a century and a half, trading in the captive market of the British empire, bringing wealth to the few and subsistence wages to the many. But from about the 1920s they have one by one been going out of business, often turning to other forms of industrial use. In recent years even that has collapsed and many have now been converted to apartments, sometimes extremely attractive ones. The long rows of mill-workers' cottages have often been restored. The result is a new kind of post-industrial, semi-suburban town along the valley floors.

AT THE SAME TIME AS THE ARRIVAL OF THE TEXTILE MILLS, THE AGRICULTURAL LANDSCAPE OF THE moors was undergoing another kind of revolution. This was the process called enclosure, and it produced the pattern of multitudinous stone walls that often seems the single most striking element of the Pennines and the North York Moors. It is true that the walls are so ubiquitous

LEFT:
The little town of Dent in the Yorkshire Dales was once a centre of home-knitters.

that the eye occasionally takes a holiday and ceases to notice them. But remove the walls and the shock would be fundamental, the moors a far less interesting set of landscapes.

Limited enclosure had taken place in earlier centuries. Medieval land use had involved the communal farming of strip-fields, with communal pastures for the animals, known of course as commons. The monasteries had nibbled away at this arrangement, building walls not so much to keep stock in as to keep other unwanted animals out. At the time of the Industrial Revolution, however, there occurred a concentration of landownership in larger blocks. In Derbyshire, for instance, lead smelting passed out of the hands of small operators

into those of larger owners who had bought the land for the lead. These new owners, and many hereditary landlords too, now began to "privatise" the moors by seizing and enclosing tracts of traditional common. For this purpose, Acts of Parliament had to be sought, and large numbers of them were passed in the period that the mills were coming into being. It was, in short, the other side of the coin of the new industrialism — though building walls, of course, was also an excellent method of getting stones out of the fields.

The Parliamentary Acts were specific about how the walls must be built — wide at the bottom and tapering towards the top, with "through-stones" to hold it all together at specified intervals. This is the reason for the wonderful regularity of the walls.

One consequence of their existence was that fields were now treated as individual units, meaning that very often a small barn was built in each and every field, as winter quarters for the animals and store-house for fodder. Nowhere is this more striking than in Upper Swaledale, where lines of barns run away across the fields like little grey counters on a Monopoly board. Another consequence was that much fresh land was taken into active farming. The new fields, described as "intakes" or "newtakes", were often the subject of intense campaigns to make them fertile. At great expense, the landowners had them drained and limed and planted with root crops like turnip. Nowadays, however, much of this hard-won land is reverting to moor.

The process of "improvement", as it was known to its practitioners, reached its most intense on the West Country moors. In 1819, John Knight of Worcestershire bought up a series of large estates that had once been royal forest. He spent the next 30 years trying to make Exmoor blossom, and in the process irretrievably changed the look of much of it.

Up to Knight's arrival there had been few buildings of any kind on Exmoor. But now he constructed a number of farms in which he installed tenant farmers, helping establish the pattern by which ploughed land comes right up on the higher ground, creating that mixed effect of moor and ridge-back farmland that is unique to Exmoor. Knight imported Scottish sheep and shepherds and Highland cattle, which were always running out of control. Around

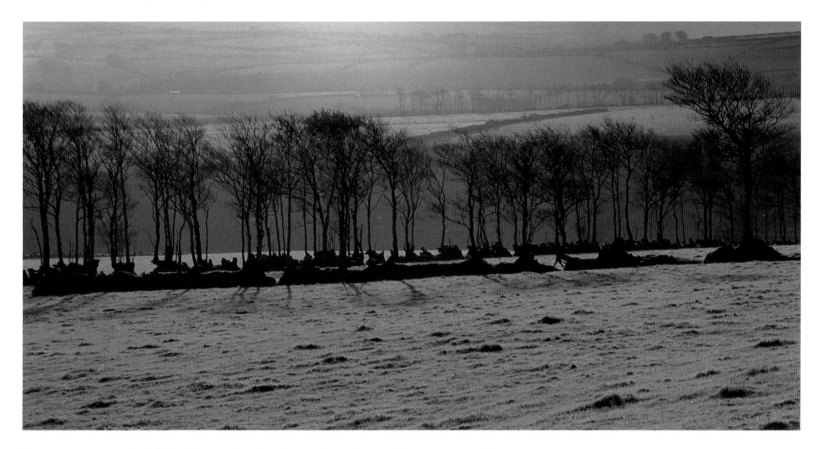

his estate at Simonsbath he built 30 miles of walling and on the neighbouring estate of Pinkworthy, "Pinkery" in local pronunciation, he dammed the headwaters of the River Barle and dug two leats in the direction of Simonsbath for some mysterious industrial purpose, never accomplished. On this high area, the famous Chains of Exmoor, his attempts at improvement failed utterly. But John Knight and his son, Sir Frederick, were successful in planting the beech woods and beech hedges that are such a feature of Exmoor today.

Dartmoor too had its famous Improver, one Sir Thomas Tyrrwhit, who by and large failed in agriculture but left a legacy of quite another form. Auditor to the Duchy of Cornwall at a young age, he also became Lord Warden of the Stannaries. In 1805 he proposed that a

ABOVE:
Nineteenth-century improver John Knight and his son, Sir Frederick, planted beech trees and beech hedges the length and breadth of their estate in Exmoor.

RIGHT:
The grim nineteenth-century entrance to Dartmoor Prison, Princetown.

OPPOSITE PAGE:
From time to time, steam trains still pound across the Artengill Viaduct on the Settle–Carlisle line.

prison should be built at Princetown. At 1,430 feet above sea level on the western side of Dartmoor, this was one of the bleakest, foggiest, most miserable sites imaginable for such an enterprise. Its purpose was to hold prisoners of war captured in the struggle with Napoleon, many at that moment even more dismally confined in hulks in Plymouth Sound.

Once granted permission, Tyrrwhit completed the prison in four years, a series of gloomy granite blocks in a style reminiscent of the Pennine mills. When America entered the war on Napoleon's side in 1812, US prisoners were soon installed here along with the French and Italians, entering under a still-surviving arch bearing the words "Parcere subjecti" — Pity the Vanquished. At the end of the Napoleonic wars the prison fell out of use for almost 40 years but opened again, with a vengeance, in 1850 and still remains in service.

THE ARRIVAL OF THE RAILWAYS BROUGHT ANOTHER REVOLUTION TO THE MOORLANDS. LINES opened piecemeal wherever a company saw a chance of business, drastically altering the

economics of trade. The new method of transport immediately put an end to many cottage industries. Pennine coal ceased to be saleable. At the same time, the railways brought in the first tourists, as opposed to the traditional horse- or coach-borne traveller.

One of the most beautiful lines ran — and runs — from Settle to Carlisle. It makes its way across the high moorland at the base of Ingleborough by a series of viaducts and tunnels, then reaches Dent station, the highest in England, 700 feet above the little town. In boyhood, the view down Dentdale seemed to the moorland writer Arthur Raistrick like a momentary glimpse through a magic door. There Dentdale lay, "a deep valley stretching away between high fells, farms like tiny toys scattered along its sides, trees, houses and cattle glimpsed for only a moment before the plunge into the next tunnel …".

Other lines are almost equally beautiful. The North York Moors in particular was soon equipped with a complex network, one line running along the south from York to Scarborough, another heading up from Pickering to Whitby and yet another steaming through the Esk Valley from Middlesbrough to reach the coast at Whitby. A whole new attitude arrived with the new means of travel, making Scarborough and Whitby into seaside resorts and opening up the beauty spots of the Esk Valley.

At the same time, in the middle of the same moor, something equally dramatic was happening. For here, in mid-century, in the Arcadian valley of Rosedale, large deposits of iron ore were discovered. With amazing speed, the quiet of the valley gave way to the clang and bang of large-scale mining. The population leapt from 500 people to 5,000. Miners' cottages were built in higgledy-piggledy rows and all kind of mining installations appeared, from winding gear and engine houses to calcining kilns tucked neatly into the long hillsides.

What made it possible, for good and bad, was the railway, which carried the ore away down the Ingleby Incline, full wagons balanced against long chains of empty ones ascending. Once more, as in the time of the monasteries, it was clear that the moors could not stand apart from the world.

OPPOSITE PAGE:
This folly stands at the foot of the climbing pitches on the Roaches, Peak District.

THE MOORS OF IMAGINATION

THE SCOTS AND WELSH HAVE THEIR MOUNTAINS. THE ENGLISH LAKE DISTRICT, THOUGH slightly miniature by comparison with Scotland, is also clearly mountain. But the English moors are something else again, that special "wilderness" mixture of peat and heather, hill and valley, tor and rocky edge, with comfortably settled farming valleys and bleaker industrial terrain. Taken in the round, the moors create a peculiarly strong impression. They evoke on the one hand mystery and dread — the fear of violence, the fear of being lost — and on the other a lively sense of possible adventure, of personal immersion in wild nature and, deeper than all of these, a sense of liberty amid the isolation.

The perceptions are based on what we have heard of the moors as well as what we have seen with our own eyes. They spring from an endlessly accumulating pool of myth and legend, literature and song. In our own century, moorland stories have inspired many romantic films and have featured as scenic and psychological backdrop to a host of television series. These range from the *Last of the Summer Wine* through James Herriot's ruefully self-mocking stories of a vet on the Yorkshire moors to historical dramas like *Poldark*. As well as their physical existence, the moors have a second life, in and of the human imagination.

Many stories have clearly arisen as highly coloured explanations of what already exists. Some may be accurate or partly so while others are utterly fantastical — a point made well enough by tales associated with the stone crosses of the North York Moors.

Lilla Cross stands on Fylingdales Moor. It is probably the oldest cross on the whole moor and may well date, as is generally claimed, from the seventh century. The story tells us that it was placed to mark the grave of a man named Lilla, courtier to an early king in the region. When would-be assassins tried to kill the king, Lilla interposed his body, dying of stab wounds in place of his lord. Who knows whether or not this tale, being so specific

OPPOSITE PAGE:
Burrow Mump, topped with the ruins of a church, is one of the strange conical hills that rise over the Somerset Levels, giving the landscape an air of mystery.

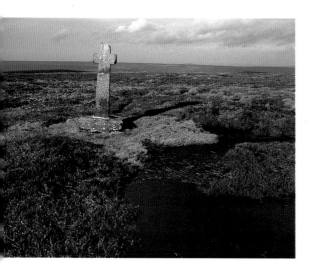

ABOVE
The Old Ralph cross above Rosedale in the North York Moors.

OPPOSITE PAGE:
St Michael's Church on Brent Tor, west of Dartmoor, lines up east-west with many other churches, most also called St Michael.

and so local, may not in fact account for Lilla Cross?

Obviously fantastical, by contrast, and with an added touch of humour, is the group of stories told of the several stones and crosses that stand on the moor above the upper end of Rosedale. There is no reason to assume that any of these are anything more than medieval, or later, waymarks. But local people used to declare proudly that their origin was tied up with a Rosedale man named Ralph and his attempt to convey a pair of prioresses over the top in fog. One was Fat Betty, the other Margery. First Ralph lost Betty, but found her again on the spot now marked by a fat, squat stone that bears her name. Then Ralph lost Margery but found her again as well (hence the Margery stone). He brought the two prioresses together at the spot now marked with his own cross, which is known, very suitably, as Old Ralph.

Then there's Young Ralph, one of the finest crosses on the moor, though it has recently been felled by gales and vandals and now stands much repaired. Young Ralph is explained as the memorial to a Danby man who died when caught here in a blizzard. A bald tale, perhaps, by comparison with the older Ralph. But much of the action lies in the future. For if Young Ralph meets Fat Betty, we are reliably informed, there will be a wedding. And the world will end if three kings should encounter one another here.

Other tales both explain natural features and have more emotional content. The story of the Richmond Castle tunnel, set in a limestone region with a profusion of underground cavities, is an example. According to the tale, a tunnel leads from Richmond Castle at the foot of Swaledale all the way to the site of Easby Abbey further down the river. Trying to plot the route, the captain of the castle guard sent down a drummer boy. He and his men listened above ground. At first the sounds of the drumming were clear, then slowly they drew further and further away till nothing at all was audible. The drummer boy was never seen again but the sound of his drumming can still sometimes be heard, even today.

This chimes in with an anecdote told to the author and photographer, in the course of their moorland travels, by farmer Ian Dent. Visitors staying at a remote cottage on his farm on the heights above Weardale in Northumberland ran down to tell him they could

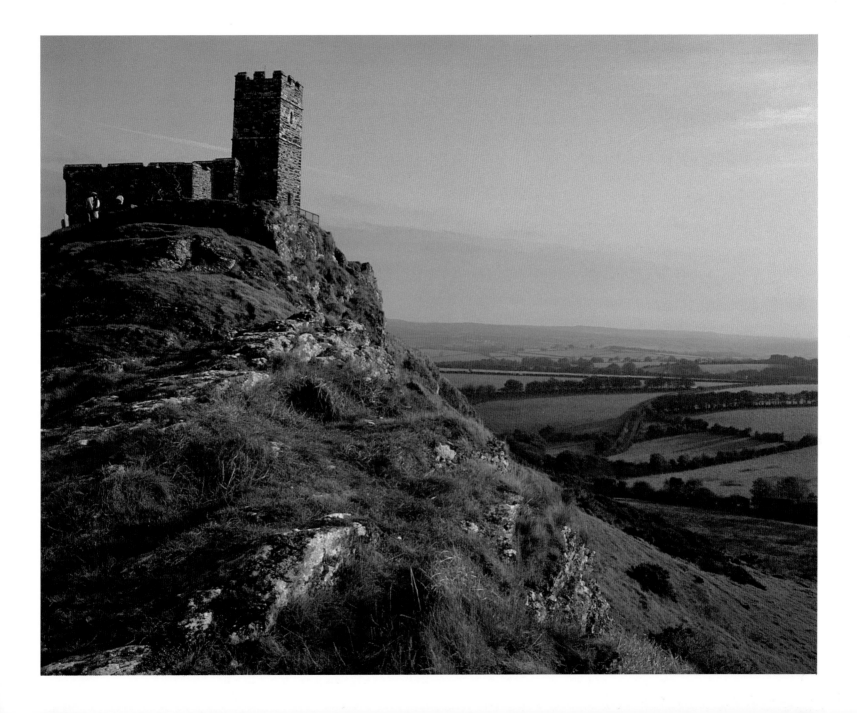

hear a lamb crying underground. Arriving at the cottage, Ian also heard the cries. He poked about in the grass and heather and soon discovered a narrow fissure in the limestone. He roped himself up, as people do in these parts when venturing underground, and then descended cautiously into the fissure. The lamb, which he successfully rescued, was standing on a ledge in the side of a huge cavern. "You could have turned round 25 London buses inside there," said Ian.

True or fantastical, moorland tales originate in many quarters. The single most popular figure when it comes to explaining oddities is the Devil himself.

There is a story, given official credence on a local signboard, that the Devil used to sunbathe by Tarr Steps, that magnificent medieval clapper bridge on Exmoor. This was a nuisance so the local vicar was sent to challenge the Devil to a swearing contest. The vicar won, of course, and the Devil has not been seen in the vicinity from that day to this.

Another Devil story comes from Brent Tor. This "tor" is a 1,100-foot-high cone of volcanic lava standing alone to the west of Dartmoor, separate from the underlying granite of the peninsula and providing the widest views available of the western side of the moor. On its summit, surmounting Iron Age earthworks, Brent Tor bears the small but pleasing church of St Michael. The locals were building a church down at the bottom, says the story, but the Devil, who couldn't believe potential churchgoers would walk the whole way up, every night chucked the building stones right up to the very top. He has been foiled over the centuries by the dutiful parishioners attending services here.

The Devil certainly gets his due on the English moors, from the West Country to the Scottish border. But if all the tales so far discussed are offered, however obscurely, by way of explanation, even more reflect the moods and fears induced by the landscape of the moors. These feature highwaymen, outcasts and murderers, not to mention ghosts.

Some incidents were real enough — as witness the stone at the base of Rough Tor on Bodmin, erected in memory of 18-year-old Charlotte Dymond, her throat cut by her lover Matthew Weeks on April 4, 1844. Her spirit is said to haunt the moorland. Other stones in

OPPOSITE PAGE:
Webber's Post on Exmoor at sunrise.

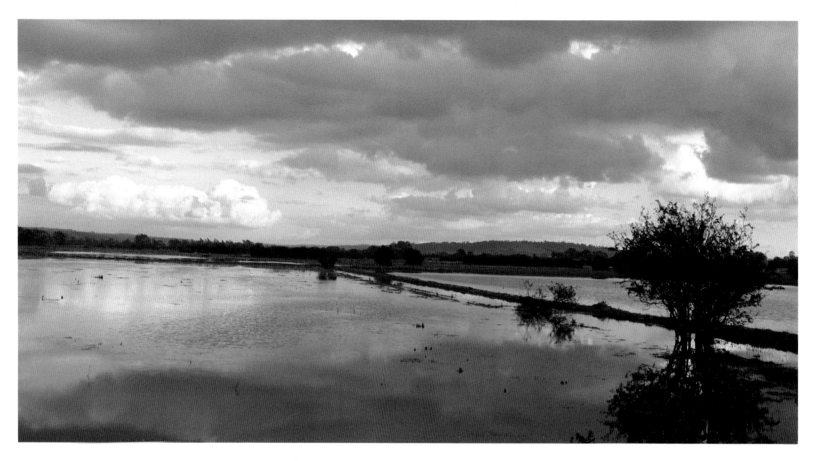

Floodwater lies on King's Sedge Moor on the Somerset Levels in winter. As the Dutch painters knew well, only flat places can produce such skies and such reflections.

the Pennine moors tell of highway robberies and killings, many accompanied by hauntings.

The moors are also a terrain for purely imaginary monsters — for example, huge black hounds of the kind that inspired Conan Doyle's *Hound of the Baskervilles*. There was the fearsome pack, also from Dartmoor, known as the Wisht Hounds and accompanied by their demon huntsman, Dewer. It was unwise, if you met Dewer and his dogs, to speak to him. But one night, after too many drinks at Widecombe Fair, a farmer met the hounds and horseman as he made his way home. "Have you had good sport tonight? What was your prey?" the farmer rashly called. In answer, Dewer tossed him a heavy sack. When the farmer

reached home and lit a lantern he saw the sack contained the body of his son.

There were other, far smaller creatures, too, more in the line of elves or pixies. In the lead-mines of the Peak District, as in the tin-mines of the south-west, there lived a little fellow called "t'Owd Man", the Old Man. Milton refers to the "Goblin or swart fairy of the Mine", so the tale of t'Owd Man's presence seems to go back at least to the seventeenth century. Until quite recent times, t'Owd Man was credited with doing his own mining, digging away with a special knocking sound. It was always wise to leave a little food for him.

The greatest problem on the moors was getting lost and drowning in a peatbog. There are naturally many stories of both, Dartmoor once again attaining pride of place.

That amusing late nineteenth-century writer the Rev. Sabine Baring-Gould, author of the hymn "Onward Christian Soldiers", tells of a man making his way home through a mire when "he came on a top hat reposing, brim downwards, on the edge."

"He gave it a kick," writes Baring-Gould, "whereupon a voice called out from beneath, 'What be you a doin' to my 'at?' The man replied, 'Be there now a chap under'n?' 'Ees, I reckon', was the reply, 'and a hoss under me likewise'."

Much of the trouble was caused by the Will-o'-the-wisp or Jack-a-lantern, known in Latin as "ignis fatuus" or "false fire", who set out quite deliberately to lead innocent folk astray. The great expert here is William Crossing, the first committed historian of Dartmoor. Crossing wrote a popular volume on the topic in 1890. As well as telling of many people "pixy-led" into all kinds of trouble, his book includes the archetypal tale of a farmer's lad way up on the moor. Distracted night after night by the melancholy cry "Jan Coo, Jan Coo", he finally followed it across the river and on to the open moor. He, like the drummer boy of Richmond, was never seen again.

ALL THESE ARE UPLAND STORIES. THERE IS ONE SPECIALLY PERVASIVE BRITISH MYTH, ARGUABLY THE greatest of all, in which the lowland moors of the Somerset Levels figure prominently. This is the cycle of romances recounting the deeds of King Arthur and the Knights of the Round

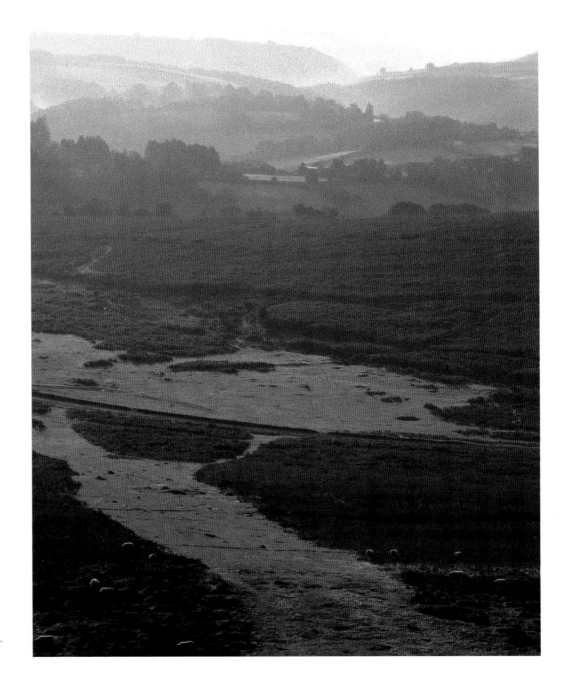

RIGHT:
Sunrise from Haytor Rocks, Dartmoor.

OPPOSITE PAGE:
A combe near Stoke Pero, Exmoor. Woods such as these are home to the red deer.

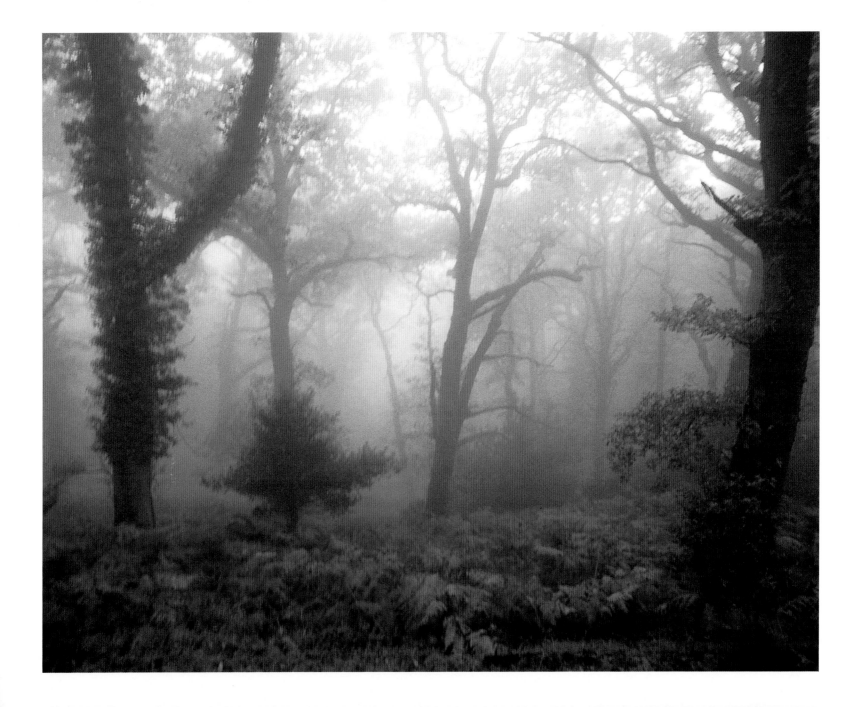

Table. Many of these stories have become quite firmly attached to places. Glastonbury and Bodmin both feature, as does a wide expanse of water lying mysteriously somewhere near one or other of them.

There are grounds for thinking that the cycle of Arthurian myth actually originates in a genuine figure, a military leader who lived in the fifth or sixth century AD, fighting off invaders and rivals on behalf of the "British" — those more-or-less Celtic peoples now dispersed through Wales, Scotland and Cornwall. All the earliest mentions of Arthur come to us in the early British language now called Welsh. They start with the Bard Aneirin round about the year 600. In the tenth century the *Annales Cambriae* or *Welsh Annals* report that Arthur fought at a battle named Badon in 518. In terms of legend-making, however, the most important of these pseudo-historical sources was Geoffrey of Monmouth, writing in the twelfth century. Geoffrey drew on much earlier written material and plenty of his own imagination, producing a fantasy history of the British kings that was generally accepted as historical record. Arthur the military leader is by now a full-scale king, ruling wisely and justly and fighting off Britain's enemies until finally defeated by the treachery of his nephew Mordred or Medraut. He wages a last and terrible battle with Mordred, the battle of Camlann, somewhere in Cornwall, and is borne off, mortally wounded, to the isle of Avalon.

Avalon, at this stage, becomes identified with Glastonbury. Here, in fact, and not in fantasy, England's leading abbey stood at the foot of that mysterious green tor that now bears the ruined church of St Michael upon its summit. Right through the Middle Ages and beyond, until the draining of the outer-lying Levels, Glastonbury looked out in all directions over classic wetland moor, a wilderness of reed and marsh and lakeland.

So potent was the story flowing from the pen of Geoffrey of Monmouth, particularly the story of Arthur's burial at Glastonbury, that England's King Henry II, round about 1190, actually caused the monks to excavate in the abbey graveyard. Here, at a considerable depth, they succeeded in finding a lead cross with Arthur's name on it and, deeper down again, a coffin made from a hollowed tree trunk containing bones immediately attributed to Arthur

and Guinevere, his queen. Though posterity has by and large considered the claims ridiculous, the declared outcome allowed the king to appropriate to the English monarchy a supposed ancestor hitherto politically tainted by his Welshness. It was also intended to scotch the rumour that Arthur was alive and would return to claim his kingdom.

The bones retained their symbolic importance and were solemnly reinterred in 1276, before the high altar of Glastonbury, in the presence of King Edward I. The Arthurian myth, in other words, was powerful enough to play its part in real events, and Arthur, Avalon and Glastonbury had been officially conflated.

Even this was only a beginning, for after Geoffrey of Monmouth the story cycle took off in the most extraordinary way. There soon featured in it not only Arthur's birth and death, but the even more elaborate tales of his Knights of the Round Table and the vastly important myth of the Quest for the Holy Grail.

This latter brought the story back to Glastonbury. In earlier centuries there had been a belief that Joseph of Arimathea had come to Glastonbury with the Holy Grail. This was the chalice that was used at the Last Supper and then again shortly afterwards to collect the blood Christ shed during his Crucifixion. Joseph had supposedly struck his staff in the soil of Glastonbury, where it became a thorn tree that flowered every Christmas. As for the Grail, now lost, the growing legend asserted it could be recovered only by a knight of absolute virtue, possessed of the necessary secret language. Given Glastonbury's associations with the Grail and the existing association between Arthur's death and Glastonbury, it was entirely natural to the developing myth that it would be Arthur's Knights who were credited with the attempt to find the Grail.

Much of the cycle was written in medieval French and German. In English, the great majority of the stories were finally bound together in the *Morte d'Arthur*, written by the shadowy Sir Thomas Malory during the fifteenth century.

Malory is moderately specific about the places involved in the tale. He puts the battle of Camlann not far from Salisbury, and he sets the lake, where Arthur's sword Excalibur is

ABOVE:
Well-dressing at Eyam in the Peak District still follows an ancient tradition; petals are affixed to wet clay in elaborate patterns.

thrown, close to a hermitage near Glastonbury. Other sources, from Geoffrey onwards, have set the final battle of Camlann in Cornwall. Of possible sites here, the best contender is the valley of the River Camel where it flows off Bodmin Moor at Slaughterbridge. If this site is accepted, then Dozmary Pool on Bodmin, with its reedy edge and long, low horizons, becomes a candidate for the lake.

One final point brings the last part of this story closer to reality. Recent excavations in peat country in the east of England, in Flag Fen, not far from Peterborough, have shown that swords were indeed thrown into sea and river in the Bronze Age, quite possibly as gifts to the gods. Could the story of the sword Excalibur have been part of a memory, even a tradition, carried down through subsequent centuries to the writers of romances? Or was it such a profound and resonant idea that it was capable of emerging independently a second time around?

At all events, there can be little disputing that the *Morte d'Arthur* is the fullest and most perfectly expressed of waterland mysteries in British literature, in many ways a commentary on the inner nature of the lowland moors.

MORE RECENT LITERATURE RELATED TO THE MOORS IS ALSO LARGE, PROOF THAT THESE WILD places continued to offer strong sustenance to the imagination. Accumulated over many centuries, moorland writing seems specially strong in the nineteenth. The Brontë sisters alone produced *Wuthering Heights* (by Emily), *Jane Eyre* (by Charlotte) and *The Tenant of Wildfell Hall* (by Anne). All three of these books, though specially Emily's and Charlotte's, are in a deep sense moorland masterpieces, placing human passion and perception alongside the desperate wildness or heart-lifting freedom of the hills. At almost every point, in *Wuthering Heights* particularly, and at a critical juncture in *Jane Eyre*, the reader reads in the presence of the moors.

Then there is R.D. Blackmore's *Lorna Doone*, a solid but romantic Exmoor tale, set retrospectively in the seventeenth century, brim-full of love and brigands. In the present

OPPOSITE PAGE:
"Lorna Doone" territory near Oare on Exmoor.

PAGE 102:
Winter on Haworth Moor.

PAGE 103:
Autumn on Haworth Moor.

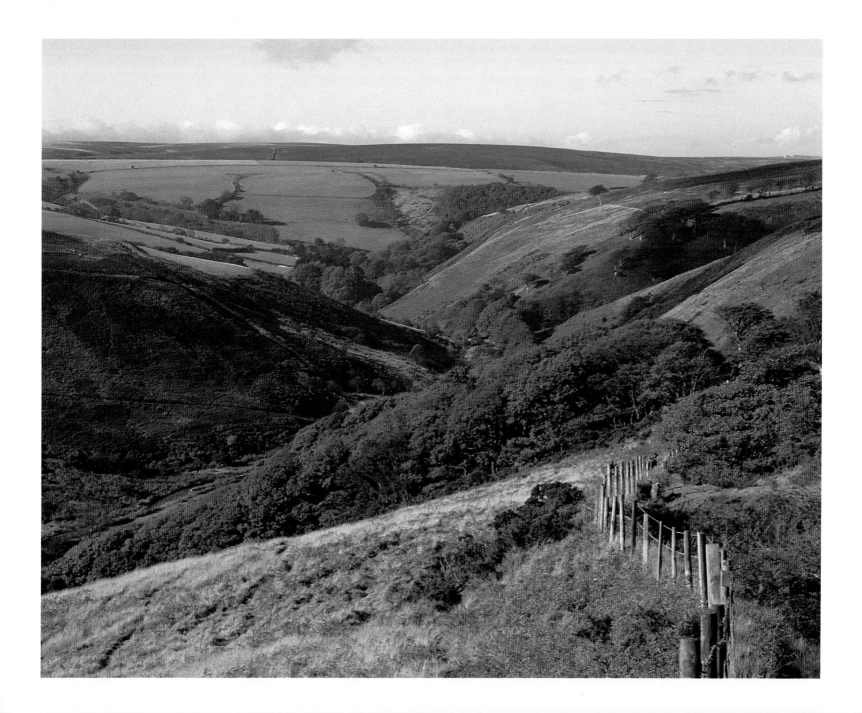

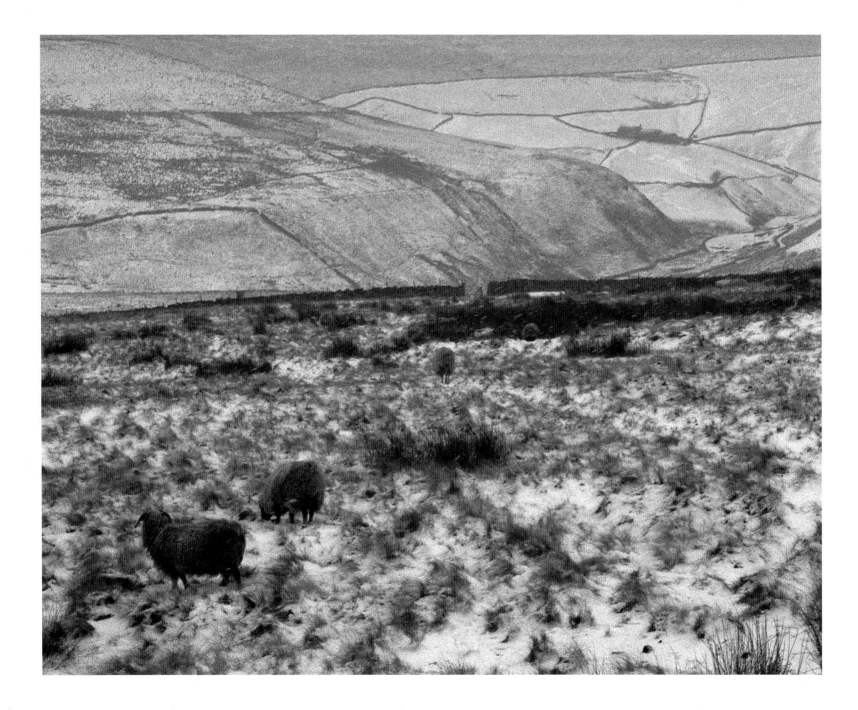

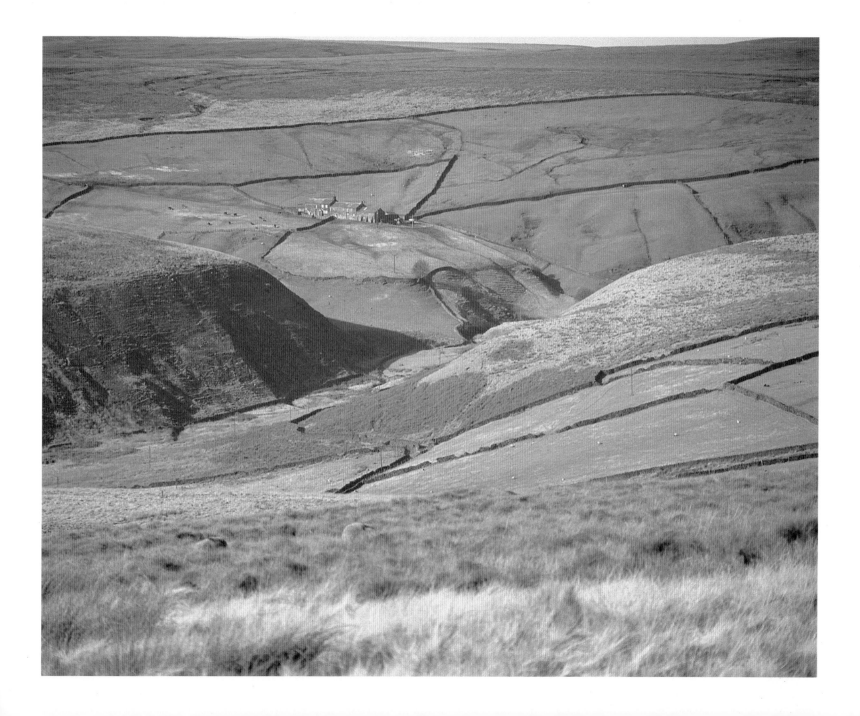

century, Conan Doyle's *Hound of the Baskervilles* is set on an imposing Dartmoor, whose grimness is itself a main part of the tale. Daphne du Maurier's wildly romantic *Jamaica Inn* has a Bodmin background. Even Frances Hodgson Burnett's *The Secret Garden* has a moorland setting (Yorkshire again, though seemingly further north than the Yorkshire of the Brontës). Surprisingly, perhaps, this story of children coming to terms with life deals as much with the moors as it does with the Secret Garden. It is nature as a whole the children must embrace before they can become full moral beings.

In addition to these familiar moorland works, most moorland areas have a local literature that is often fascinating in its own right. This ranges from Thomas Armstrong's Pennine mining novels to the Dartmoor stories of writers such as Beatrice Chase or Eden Philpotts.

ONE PHYSICAL STARTING PLACE FOR AN EXCURSION THROUGH MOORLAND LITERATURE IS IN THE Cheviot Hills, border country long fought over by Scots and English. Nowadays, this beautiful and — by British standards — empty area, the emptiest in England, consists of round hills mostly under grass. But all around there still survives a hoop of dark and threatening moorland. This is home to the wild cattle of Chillingham, an indigenous breed preserved over centuries within stone walls. In the old days, much of the Cheviot countryside was forest, in the medieval sense of hunting ground. Here, at Otterburn in 1388, the English Earl Percy of Northumberland was defeated and captured in a ferocious border battle by the Scottish forces under Earl Douglas. Douglas himself was killed. Within a century this affray had become the subject of the mournful ballad of Chevy Chase, all greyhounds, fallow deer, the greenwood tree and aristocratic heroism, and including, at the end, the standard lamentation for the dead. The ballad survived for many generations in the oral tradition, finally emerging into print in 1765, in a publication by Thomas Percy called *Reliques of Ancient English Poetry*.

Meanwhile, the moors began to receive a different kind of literary attention. Take the case of the Peak District. In the seventeenth century, the philosopher Thomas Hobbes was tutor to the children at Chatsworth, the Peak District home of the Dukes of Devonshire.

OPPOSITE PAGE:
The Brontë sisters enjoyed walking across these rough fields and moors near Brontë Falls, above Haworth, West Yorkshire.

Hobbes wrote a long and ponderous Latin poem called "De Mirabilibus Pecci — Concerning the Wonders of the Peak". In it, Chatsworth featured in a list of seven "wonders" encountered in a two-day ride. Daniel Defoe, before the end of the eighteenth century, was referring to Derbyshire as "a howling wilderness ... the most desolate, wild and abandoned country in all England". This became the standard perception during the eighteenth century — that the English moors and uplands, as represented by the Peak District, were pretty dreadful places but contained a number of fixed points of considerable interest.

The Romantic poets, especially Wordsworth, totally overset this way of thinking, turning hungrily to Britain's wildest landscapes in search of the sublime, the transcendental, even the revolutionary. Although much of the search was conducted in the Lake District, it is worth remembering that Wordsworth made visits to Yorkshire and Wales and that he and the poet Coleridge spent a spell together on the Somerset side of Exmoor; here they produced that extremely significant joint work, the *Lyrical Ballads*, published in 1802. In Scotland, Percy's *Reliques*, among them the ballad of Chevy Chase, were proving a deep inspiration to the poet and novelist Sir Walter Scott. He, as it happened, spent key moments of his life in the Cheviots, and his work flowed unimpeded into the wide stream of the Romantic movement. If the "extra" of the Gothic novel is now added — as represented, for example, by Mary Shelley's *Frankenstein* of 1818 — then some of the background has been assembled to that amazing flowering of the imagination that took place in the 1840s, in and round the little parsonage at Haworth, not so far from Bradford, at the southern end of the Yorkshire moors. For the Brontës counted Walter Scott their literary hero, intensely admired Wordsworth and the other Romantics, and showed in their work more than a trace of the Gothic.

CONTEMPORARY VISTORS TO HAWORTH WILL FIND A STEEP, RATHER PRETTIFIED LITTLE TOWNSHIP, once, but no longer, a place of textile mills and poverty-stricken homeworkers, their looms installed upstairs in the terraced cottages. The parsonage, classical in style, has had a Victorian wing tacked on since the Brontës' time, not to mention an ugly extension at the rear

to serve the Brontë museum — which is, of course, what the parsonage has now become. Opposite the house, across the graveyard, the nave of the church has been replaced with a newer version while an extra storey, complete with clock, has been added to the tower. Behind, up past the site of a former quarry which was busy in the Brontës' time but nowadays lies derelict, the moors go sweeping away directly from the house.

Unless you come in the deep of winter, you will probably find yourself in competition with a great many visitors. But the crowds are accommodated one way and another while parsonage and town and the moorland round about remain deeply evocative, almost uncomfortably so. Perhaps the feeling of discomfort is due to the early deaths of all three sisters, and of their brother Branwell, combined with the proximity of the parsonage to the sombre graveyard. More than 40,000 people are said to be buried here; Haworth had a death rate equivalent to that of the worst parts of Victorian London. Water was hopelessly polluted by the graveyard; cholera, diphtheria, typhus and tuberculosis were endemic. But even more than this, the sense of vividness resides in the novels themselves and in their umbilical connection to the moors.

It was Emily who was held by her sister Charlotte to be the most deeply committed to the moor. Among the many, many references to the moorland and its weather in *Wuthering Heights*, perhaps the most moving of all is the repeated suggestion that the moor can be equated with hope and life itself. For Charlotte, however, the moors always appeared more dangerous and threatening. There are many stories of her timidity over animals and heights and it was the younger Emily who cajoled and sometimes tricked her, on the sisters' moorland walks, into going further into the wilderness than she intended. So it is not really a surprise that in *Jane Eyre*, Charlotte's greatest triumph, the moor represents danger, loss, exposure, the final deep of the abyss. Anne Brontë, on the other hand, in her disturbing book *The Tenant of Wildfell Hall*, at first glance uses the moorland mainly as a setting. In *The Tenant*, as opposed to *Wuthering Heights*, it is the distant prospect of the sea, and not the moors, that offers peace and easement.

OPPOSITE PAGE:
Haworth Parsonage is situated across from a crowded graveyard.

Reading the book and knowing of Anne's deep attachment to Scarborough and the sea — she was to stay in Scarborough, rather than in Haworth, during her fatal illness — it is easy to feel that the setting is the North York Moors. Equally, in *Jane Eyre*, it seems from Charlotte's life story and from the detail of the description when the heroine escapes from moor to village, that the place she has in mind is Hathersage in the Peak District. As to the origin of *Wuthering Heights*, most people believe that Emily was inspired by the farm of High Withens on Haworth Moor, now a much-visited ruin.

It is fun, undoubtedly, to explore these possibilities. My own feeling, however, is that too much of this approach may distract from the novels themselves, and from their elemental universe. Haworth itself has a clear importance since the contradiction between the fever of creation in the parsonage and the horrifying but majestic graveyard remains so readily apparent. For the rest, what really matters is to gain experience, imaginatively or in reality, of the moors.

One could say the same, perhaps, of most moorland literature. But two exceptions seem worth making. One is R.D. Blackmore's Exmoor where the topography of *Lorna Doone* is so tightly wound around the author's childhood places that part of the pleasure is to see how his imagination has worked upon them, from the waterfall that his hero, young John Ridd, so daringly climbs to start the proper action of the story — rather a modest waterslide over a sloping rock — to the hidden retreat inhabited in his imagination by the murderous Doone clan. This is a quiet moorland vale, its entrance hidden by a tree-grown mound.

The other writer of deep topographical interest is from the present century, controversial later in his life for ugly fascist views, but among the most brilliant and empathetic of England's many nature writers. I am speaking, of course, of Henry Williamson, author of *Tarka the Otter*.

A "Tarka Trail" has been established leading up and over the Chains in Exmoor and through the lovely countryside of the River Torridge where much of the story takes place. In the novel, and, one may think, in actuality, this is a poetically charged world of water, tree-roots, gravel banks and pools, of bridges and quiet river-bends where herons watch over the

shining waters and over the fields and copses traversed by the otters. But it is also a world where almost every animal kills others that it meets on sight and where the human race is unbearably cruel. The hunting of otters, which is near the centre of the book, was banned eventually and the otter was given full protection under the Conservation of Wild Creatures Act in 1978; in *Tarka* the theme is expressed in the mortal struggle between the otter-protagonist and the great hound Deadlock.

There is a moment in the story where Tarka penetrates to the heart of Exmoor, following the highest watercourses, to emerge by Pinkworthy Pond, John Knight's artificial lake. Williamson writes:

> Within the moor is the Forest, a region high and treeless, where sedge grasses grow on the slopes to the sky. In early summer the wild spirit of the hills is heard in the voices of curlews. The birds fly up from their solitary places, above their beloved and little ones, and float the wind in a sweet uprising music. Slowly on spread and hollow wings they sink, and their cries are trilling and cadent, until they touch the earth and lift their wings above their heads, and poising, loose the last notes from their throats, like gold bubbles rising into the sky again. Tall and solemn, with long hooped beaks, they stalk to their nestlings standing in wonder beside the tussocks… . Soon the curlew lifts his wings and runs from his young, trilling with open beak; his wings flap and he flies to fetch song from heaven to the wilderness again.

It is for doing something similar that we must thank the moorland writers and the moorland legends.

THE LIVING MOORS

THE MOORS ARE VIVIDLY ALIVE AND LIKE ALL LIVING THINGS PERPETUALLY IN MOTION. TO SEE what exists right now involves an attempt to stop the clock, if only for an instant. But the second the clock begins to tick again, change reasserts itself and the moorlands, lowland as well as upland, start once more to become a different landscape. An observer can only point to the main features and some of the main changes underway.

From the visitor's perspective perhaps the most important fact about the upland moors today is that most of their acreage now falls within a network of National Parks. Dartmoor and Exmoor each have a National Park named after them, as do the Peak District, the Yorkshire Dales and the North York Moors. The Cheviots and their associated moorland fall within the Northumberland National Park. All of these are dedicated to preserving the natural beauty of the areas they encompass, promoting their enjoyment by all comers and ensuring the well-being of the communities who live there. Unlike national parks in the United States and many other countries, those of England and Wales own only the tiniest fraction of the land. Ninety-nine per cent remains in the hands of the existing owners: farmers, landed aristocrats, retired folk from the towns, business syndicates, forestry interests, even the military.

So the parks are only public in the broadest sense. But they do respond to the deep belief among the British people that at some level the experience of the wilderness belongs to all of us, even if the surface of the land remains the property of others. This long-latent way of thinking developed into a positive campaign during the 1930s, at a time when the hills were entirely in the hands of the landlords and no public rights in them were recognised in law, apart from established roads and footpaths and the grazing rights of villagers and farmers. Large upland areas, particularly the Pennines and the North York Moors, were run as grouse shoots by the great proprietors. These people and their gamekeepers shared the aim

OPPOSITE PAGE:
The Howgill Fells in the Yorkshire Dales, poised between the Lake District and the Dales proper.

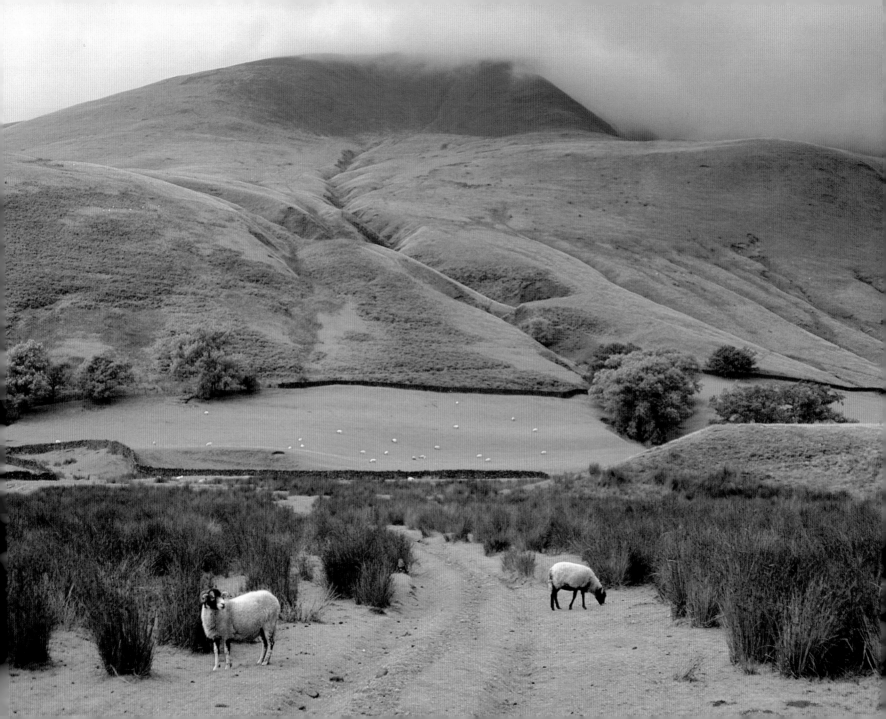

ABOVE:
Alan Smith serves excellent sandwiches from his van in the car park under Hound Tor, Dartmoor.

of keeping the general public off the land. But the public, particularly those who lived in the industrial cities round the moors, had come to see the open spaces as part of their own birthright, as well as being the best of all possible antidotes to the misery, ill-health and unemployment of the industrial population in that period.

It was perhaps inevitable that the conflict should come to a head in the Peak District, ringed round as it is by more towns and cities than you can count on the fingers of two hands. Meetings of ramblers and hikers were held, some drawing up to 10,000 people, demanding free access to the moorlands and the establishment of "national parks". Finally, the activists decided on a "mass trespass" on the grouse moors of Kinder Scout, on the western side of the Peaks. On April 24, 1932, 400 walkers set out for the uplands, only to meet a small party of gamekeepers under the high edge of Sandy Heys. There were blows between the two sides and scuffles, followed by arrests. Five of the ramblers were imprisoned, drawing huge publicity to their cause. Similar but less dramatic "trespasses" took place elsewhere.

Following World War Two, the incoming socialist government remembered these events and pushed through the legislation to set up the National Parks. It was a reflection of the idealism of the time, intended, in the aftermath of so much destruction, to preserve the wild, high places for succeeding generations. The other intention was to offer the British people the freedom of the hills, an opportunity to challenge the wild country and the elements. The possibilities were seen, explicitly, as spiritual.

In England, the first National Parks were designated in the Peak District, the Lake District and Dartmoor in 1951. They were followed by the North York Moors next year, then by the Yorkshire Dales in 1954 and Northumberland in 1956. As recently as 1988 a new member of the Parks family was set up, the Broads Authority, covering the waterway network of old peat cuttings in Suffolk and Norfolk. There is none, however, to cover the Somerset Levels.

As the Parks were established, so access agreements were reached with many landlords, particularly in the Peak. Through this two-pronged approach the moors and mountains were opened up to ordinary visitors.

The result has been a "leisure explosion" on the uplands, with a host of resulting pressures and conflicts. But let it be said at once that the vast public response to the opening of the hills — now something in the region of 100 million day-visits a year to the National Parks — has shown how necessary it was to set up the park network.

It was assumed from the beginning, to use the words of the Peak District writer K.C. Edwards, that the great majority of people would "find their enjoyment in traversing

RIGHT:
Farmer Ian Dent of Westernhope Moor, above Weardale, looks on while the vet scrubs down in preparation for delivery of an awkward calf.

the hilly ground, observing the magnificent views and breathing the upland air". So it has mostly proved, with walking by far the most popular pastime on the moors. A breakdown of activities on Dartmoor, for example, reveals that over a third of visitors go walking or hiking. On the other hand, almost a quarter stay in their cars or take the shortest of strolls nearby. Though this is rather shocking to outdoor enthusiasts, and was not anticipated by the founders, it does at least reduce the number on the paths during the busiest times (in particular, Bank Holidays and summer weekends during the school holidays). One in six of Dartmoor's visitors come to the hills to picnic. A smaller number go horse-riding, mountain biking, visit paying attractions, take part in nature study or exercise their dogs.

On other moorlands, there are even more activities — rock-climbing, caving and pot-holing, canoeing and hang-gliding. There have also crept in here and there a number of noisy sports and pastimes, from occasional motor cycle and car rallies to four-wheel driving on private parts of the moor and even microlight and helicopter flights. By the early 1990s this had reached the point where the National Parks and their supporters began to call for a new law, redefining the purposes of the Parks. They wanted to slip in the word "quiet" before the promise of "enjoyment" and to add "understanding" as one of the objectives. The aim was to return to the original vision.

On the one hand, then, the upland moors have been thrown open to the people, eliciting a huge response and naturally creating pressures. On the other, quite as important for present and future, there is the continuity represented by the farmers.

ABOVE:
A farmer's personal request on the North York Moors.

UPLAND FARMING HAS NEVER BEEN EASY. EACH SMALL INCREMENT OF HEIGHT ADDS considerable harshness. Above all, however, the question of the winter, how long it is and how severe, determines the success or failure of the farmer. Much upland farming is carried on, not with the elements but in opposition to them. Maybe this gives the moorland farmers so distinctive and self-reliant a temperament. Pennine dwellers have a reputation for "never bowing the knee to anyone" and the same is broadly true of moorland farmers everywhere. They are a craggy, canny lot, warm in friendship, not so agreeable, perhaps, as adversaries.

"You have to understand how different we are from lowlanders," one Cheviot hill farmer tells us. "If you go to a farming party in the lowlands, it is like meeting the gentry. They are all wearing blazers with shiny buttons. But if you visit in the hills, you will find old tweeds instead. We are not so dominated by the clock, more by the task in hand; there's usually time for a coffee and a chat. There's another difference, too. Lowland farmers are hidden away in their cornfields, but you'll certainly come across us hill farmers out on the moors. We are probably the most visible of all."

These hill farmers live on the moorland slopes or in the valleys. About half of their

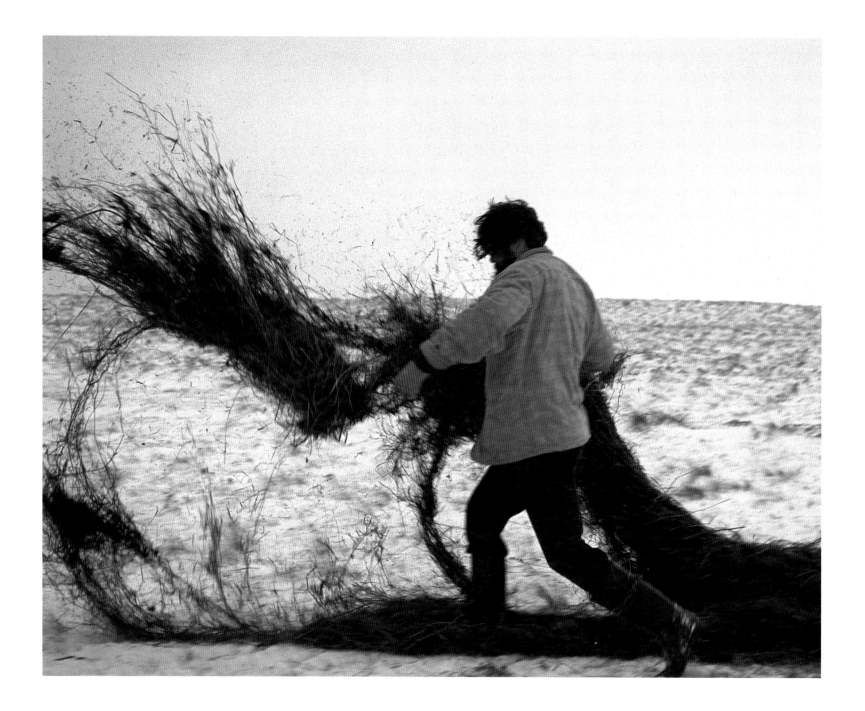

business is sheep rearing, with lamb for meat and the fleeces of the flock for wool. Most farms also rear "store" cattle — "unfinished" beef animals to be sold lower down the hill for fattening. Others go in for dairy cattle, though not so heavily as before. Some make cheese. In the Yorkshire Dales, for instance, there is a range of local cheeses — Wensleydale, Swaledale, Ribblesdale, Coverdale.

The farmers move up to the open moor to attend to stock and, particularly in late winter, for "swaling". This is the burning of patches of heather, in a long rotation, to keep it "in good heart" for sheep.

Sheep predominate on all the moors. The preferred breeds are naturally the hardy hill varieties, with Scottish blackface and Swaledale the most common. Where a farmer has the right to run sheep on the moor, known in the north as a "stint" or "gate", each flock occupies a traditional territory. This is called a "heft" or "heaf". Generation after generation of the same flock will live on the same piece of ground, passing down local knowledge and habits. If a flock is moved or scattered, it will reassemble on its native heaf.

Shepherding is hard work and no mistake. There is the testing task of winter feeding, with plenty of dipping and drenching — medication of various forms — at particular points of the year. But the time of greatest intensity, and risk, is lambing with April the main month on the high ground. For the farmer there is lots of walking round the fields and in-byes and plenty of anxious nights as he tries to help ewes in difficulty or when there are "orphan" lambs to be rescued, surviving after the mother has perished.

Shearing takes place in early summer. This is another hectic period, though nowadays the actual cutting is mechanised, greatly shortening the time taken. Gone is the festival atmosphere of former times when gangs of itinerant shearers, and just about everybody else in the neighbourhood, came to help. "Ah," says an Exmoor farmer, "we knocked back plenty of cider in those days, at shearing and harvest time. But nowadays it's only a few of us. Helpers arrive by car and they have to be careful about drink. They just line up for the cheque at the end of the day, say 'ta ta' and they're off."

ABOVE:
Farm sign near Gayle in the Yorkshire Dales.

OPPOSITE PAGE:
Feeding sheep in winter on Goathland Moor, North York Moors.

That, in the end, is the real problem. There are too few people on the land and the number is still diminishing. Everywhere you go, you hear the sound of nostalgia and lament, coupled with a feeling that the old ways were better.

On Dartmoor, David German, now in his hale and hearty 50s, takes us down to Fox Tor Mire, the deepest peatbog on the moor. "Look," he says, "here is where my Uncle Ernie used to live. He'd be riding bareback to round-up the sheep and he'd treat me like a second dog — 'Get out over, there's another on'em.' I'd run and run and he'd never let up. But in the evening Auntie Mabel gave us pigs' trotters and thunder and lightning — home-made bread with clotted cream and black treacle. We had our own pigs, with lots of greasy bacon."

Uncle Ernie is gone and so is Auntie Mabel and where David's father farmed there is only the forbidding mire and the long low hills behind it, remains of tin-mining and a rubble of fallen rocks. This rubble was once the farm. "Look," says David, gesturing upwards at thin air, "that was my bedroom. On summer nights I could look out and sometimes see the will o'the wisp playing over the mire."

Up in Weardale, at the far end of the country, old Mr. Ray Dent, father to Ian of the underground lamb-rescue expedition, tells us of the traditional moor grasses, the fescues and mosses, and the rushes that provide shelter for the grass at the start of the growing season. "There aren't a twentieth of the small birds nowadays," he says, "no trout to tickle in the brook." As for machinery, it separates a farmer from the hills around him. "Just you and your dog, that's a challenge. But when you work with machinery you switch off and you are finished. Working directly with livestock you are working with your conscience."

WHAT HAS HAPPENED IS THAT DURING THE LIFETIME OF MR. DENT UPLAND FARMING IN BRITAIN has changed more than it has ever done before within historic times, including even the period of the enclosures.

These near-contemporary changes began with the arrival of wheeled traffic on the moors about the time of World War One. Until then, almost all goods had been carried either by pack

OPPOSITE PAGE:
Open-air sheep-shearing beneath the crags of Hen Cloud in the Peak District.

animals or on horse-drawn sleds. The tractor came with World War Two. The consequent disappearance of the horse dealt a mortal blow to blacksmiths as well as specialist ploughmen. Along with the horses, farm-workers and their families now began to vanish from the high ground.

Rural depopulation happened everywhere, of course, but hill-farming, at best economically marginal, was worst hit of all. By the 1950s and '60s, it was sustained only by government subsidies. With a hang-over of war-time mentality, these were designed to increase production by means of "efficiency" — meaning still fewer men, more machinery, and more chemicals. Some of the latter were extremely harmful and help to explain the absence of Mr. Dent's small birds and trout. There was scant notion of conservation in government policies. On hill-farms where there had once been pigs and geese and chickens to accompany the sheep and cattle, with a little bit of this crop and a little bit of that, now it was goodbye to almost everything that could be considered extraneous. Farmers began to specialise, going in mainly for sheep or store cattle or dairying on the lower ground, in what looked more and more like a drift to monoculture. Subsidies were — and still are — paid per head of cattle; overstocking and overgrazing naturally ensued. In many places, especially Exmoor, the dwindling band of farmers felt such pressure that they actually ploughed up large quantities of moor. But though the whole proceeding was entirely artificial and in some ways extraordinarily injurious, at least a proportion of the farmers remained in place, occupying the hills, their traditional "workshop".

Then came the decades of overproduction, not just across Britain but through the whole of the fast-developing European Community (now the European Union) with wine and milk lakes, beef and butter mountains, all created by agricultural support schemes. Policy, in response to this embarrassment, began to change. Production quotas were brought in; support prices at market were lowered; and schemes were introduced for taking land out of agricultural production. The imposition of the milk quota, in particular, caught some farmers out extremely badly, persuading them to return to at least a measure of diversification — one reason why most hill-farms now keep both sheep and cattle.

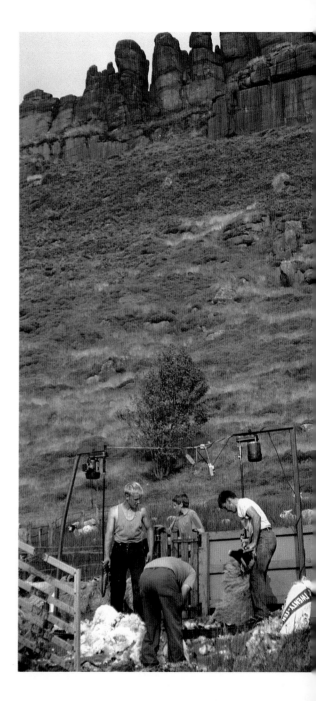

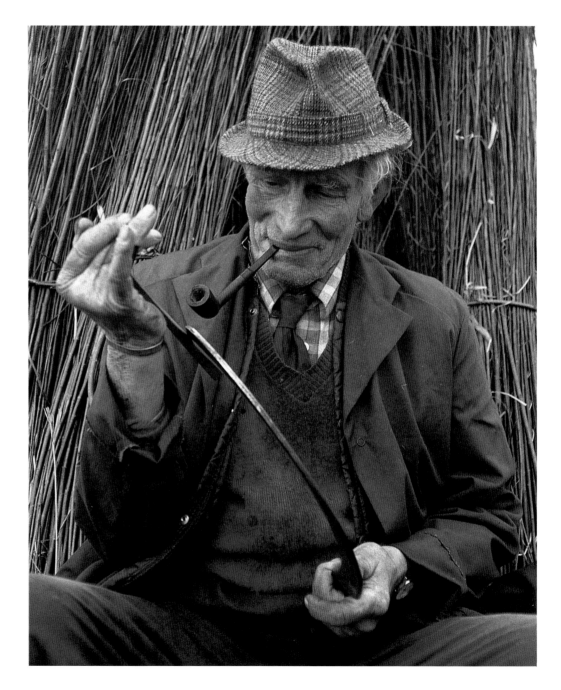

RIGHT:
Charles Keirle, one of the last of the traditional withy workers in the Somerset Levels, sharpens his blade for cutting withies, the flexible young shoots of young willows.

LEFT:
Withies stacked like the corn stooks of former days.

All this, in a real sense, was reform by restriction. On the more positive side, as "green" consciousness started to develop, the National Parks Authorities and other countryside agencies began to offer grants and special arrangements for farmers willing to work in better harmony with the moorland environment. This meant, for example, exchanging an element of intensity for the better preservation and repair of stone walls; keeping up traditional buildings, hedges and so forth; and not using fertiliser on the "newtakes", that outer rim of enclosed farmland that has most recently been taken from the moor. Traditional meadows began to return. A great many Sites of Special Scientific Interest (SSSIs) have been established since the late 1960s, despite some grumbling among farmers, to protect local habitat and wildlife species, from ancient woods of stunted oak to colonies of fritillary butterflies.

RIGHT:
At a grouse shoot in County Durham, the "gun" (left) and "loader" chat in the butts while waiting for the drive.

The money available through upland conservation is only a fraction of what can still be earned through straightforward farming subsidies and it comes from a host of sources, making grant applications a nightmare of bureaucracy. Even so, a start has been made in the attempt to maintain traditional farming activities in and around our wilderness areas. As a result, such popular entertainments as sheepdog trials continue to flourish and market day retains at least some of its liveliness.

The wider economic forces are still set strong against old-fashioned farming. Ever-larger units of land are necessary to make a living and as the older generation dies and the small farms fall vacant, the younger people leave, unwilling to carry on. The land itself is bought by the larger farmers while the old houses are often sold to incomers from the towns, people who may want an acre or two to keep a pony for the grandchildren but have, as yet, no rural background. Village schools continue to close. Shops and post offices are often kept open only by the presence of tourists during the summer months. The future looks decidedly perilous.

PERHAPS IT IS A MERCY FOR THE MOORLAND THAT GROUSE SHOOTING, THE PASTIME THAT LED TO the great confrontation of the 1930s, is now doing so well. For as sheep values have declined, the number of rich folk willing to take a tilt at grouse-shooting, at literally thousands of pounds a day, has continued to grow. This makes it the most profitable use of land available to the owners of heather moors. Since the grouse depend entirely on the heather, it follows that great efforts go into the heather's preservation and improvement. This is one of the chief tasks of contemporary gamekeepers; their contribution far exceeds the "swaling" of farmers. "Somebody has to manage the moors," says an officer of the North York Moors National Park, "and we are extremely grateful to them."

To many visitors, red grouse, with their loud "grockle" call, are the very spirit of the northern moors (they exist in the West Country, but only in small numbers). The birds pop up as you walk, observing you from ridges and other vantage points, then moving on with

LEFT:
The dogs wait to collect the fallen grouse when the drive is over.

their fast but rather heavy flight, lurching and whizzing through the air. They are truly wild creatures, averaging about one pair to every five or six acres in good grouse country, and able to survive even the fiercest winter on the moors. But they do need heather of differing ages — young buds and shoots for feeding on; "middle-aged" heather for breeding in; and old and bushy heather, perhaps 20 years old, for survival in the snow. So the gamekeepers burn off strips of the old heather, 30 to 40 yards wide, in carefully selected spots, ensuring a good sequence of ages for the future. It is a delicate operation. If the wind gets up and the blaze goes too fiercely, it will take many years for the heather to grow again. If the weather is too dry, the underlying peat may catch and smoulder uncontrollably over wide areas. Gamekeepers say there are only about 14 days a year when the conditions are just right.

Grouse shooting itself, starting on August 12 each year, is the most spectacular theatre on the moorlands. The hunters, known as "guns", are often a mixed group. There will be old-fashioned, well-to-do countrymen, thoroughly acquainted with the "form", along with newcomers hoping to buy in to a sport that promises social elevation and the thrill of the chase. After a hearty breakfast at hotel or shooting lodge, up they go to the moor. Dogs, loaders, beaters and keepers await them, in a clear social stratification that is never breached, no matter how comradely the appearance on the surface.

There will be several drives during the day. The butts from which the guns will shoot, wooden or stone-built emplacements with turf on the front wall to rest your elbows on, are arranged in a long line. The guns are splendidly dressed in dense tweeds. With each successive drive they move one place along the butts, so that sometimes they will be stationed in the centre of the line, sometimes along the edge. And now, when they and their loaders are in place, the beaters begin to close in, hallooing and bashing the heather, moving the grouse in front of them. "Flankers" walk along the side, hoping to turn back any grouse that try to fly out sideways. The guns wait with increasing concentration, till suddenly a loader cries "two o'clock", or three or four or five o'clock. Up goes the shotgun to the shoulder, and BANG — the heavy, compact bird gives off a trail of feathers and goes hurtling down to death, or else,

OPPOSITE PAGE:
Careful burning of the heather on the North York Moors helps keep the grouse moors "in good heart".

escaping past the butts, tries to break free in a wild surge of flight.

After each drive, there comes a picking-up session, with dogs and people scurrying about the moor in concentrated activity. Now the dogs come into their own, quartering the fells under the directions of their handlers, with wonderful speed and enthusiasm. And soon, after another session or two at the butts, there will come a sumptuous lunch followed by more shooting in the afternoon. Grouse numbers fluctuate and there is some fear that we are at present witnessing a serious decline. But even so, the little corpses pile up under the eye of the gamekeeper. He will have to keep a tally and dispatch the greater part of the day's kill to the game butcher.

There are plenty of wet days when no shooting is possible and insurance policies are invoked to compensate for the money lost by the owner-organisers. But on a good day, with sun shining and a mild breeze blowing, the scene is both exciting and physically beautiful — heather in bloom across the moor, the men (there are hardly any women) in their ritual finery, the elaborate and expensive shotguns, the well-trained dogs, the atmosphere of intensity and subdued excitement.

Is it sport or is it simply killing? The question applies not only to grouse shooting but also to other forms of hunting practised on the moors — stag-hunting with hounds on Exmoor, beagling for hares (now very limited), and fox-hunting, still common throughout the English uplands. It is an important question, since for every person who engages in hunting there are several who consider it a cruel and defiling occupation.

"Are you one of those 'anti's'?" a landowner asked me as he gave me a lift one day at the moor's edge. "I'll tell you what they are — stinking, foul, smelly, filthy-haired, nose-ringed. They're criminal, that's what they are." The "anti's" feel the same indignation in reverse, many disliking not only the shedding of blood but the wealth and social position that frequently go with it. There are clear elements of class war in the dispute as it rages across the countryside and moorlands, with hunt sabotage and sometimes violent flare-ups. There have even been deaths. The issue has become politicised. The Conservative government has

brought in new laws to control the opponents and continues to support what it euphemistically calls "field sports". Most of the rest oppose what they refer to, with naked accusation, as "blood sports". Labour and Liberal Democrat local governments have in many places banned hunting on land in their ownership and there is some prospect that hunting with hounds may in the end be banned on a national basis. As for grouse shooting, the questions are even more difficult, since whatever we may think of it, the activity remains crucial for the survival of the moors.

Compared to this, the question of access to the grouse moors is a small one. But gamekeepers differ in their views. Some see the public as an unmitigated nuisance and try, quite successfully, to make life unpleasant for walkers. Others, like Alan "Coggie" Bowes, a gifted naturalist and one of the best-known keepers in the North York Moors, are far more understanding. "It's not quite open access, in the sense that you are supposed to keep to the paths," he says. "But I'm a great believer in walking and I love to see town people up here, walking and enjoying themselves."

"But it really makes my blood boil," he goes on, "when people come up in their cars and then leave litter to blow about the moors."

The farming community shows the same ambivalence. Charles Armstrong in Northumberland, for instance, says he is genuinely happy to meet the walker-hiker and enjoys the company. Like many upland farmers, he and his wife do bed and breakfast and they believe that they and specially their children get a lot out of visitors. "It stops us just being country cousins," they maintain.

Other farmers, perhaps more numerous and vocal, complain of trodden-down crops, of gates left open or swung upon, and over and over again of badly controlled dogs harrying the moorland sheep. Some farmers will not take up grants if the terms involve public access to their fields. "We are giving away our rights over our own land," says one of their Dartmoor spokesmen darkly.

What is absolutely clear, both on farmland and on grouse moors, is that the walkers

will not go away. It is equally true that it often falls to the National Park Authorities to attempt to mediate, negotiating access where possible and encouraging landowners to take a more open attitude. The Parks try to explain to townies how to enjoy themselves while still respecting the needs of others. Park information centres, Park rangers out on the hill, support for the growing network of long-distance footpaths, a multitude of guided walks with professionals on hand — all these have proved useful responses.

Walkers cause other problems out on the open hills. The worst is erosion and the trampling of the peat, in ever-widening trackways, turning a path into a quagmire. All kinds of techniques have been used to try to keep the paths in passable condition, from revegetation using "hydrosprays" — these shoot out seeds, water and fertiliser all in one — to plastic "geotextile matting" spread on the peat as a support for fine stone aggregate. Along the much-travelled Pennine Way, Britain's longest and most arduous footpath, running on moorland heights nearly all the way from the Peak District to Northumberland, you may well meet a helicopter ferrying in flagstones to repair the path. The irony is that the flagstones were dug originally from moorland quarries for the textile mills of the industrial revolution. Now, with the mills silent, the flagstones are returning to the moor.

If there are problems with walkers, caused essentially by numbers, these pale compared to the problems caused by the car, main weapon in the leisure invasion. "Drive moor carefully," say the roadsigns on Dartmoor, trying to strike a little humour from the conflict. But really it is no joke if we wish, as we must, to keep our last wild places from becoming an extension of urban sprawl.

Yet what are we to do? Hill country public transport has virtually collapsed. Only the car provides the freedom of movement that makes the hills accessible. Yet the car is making that freedom at times intolerable. The majority of visitors to National Parks arrive by car and more and more are expected in the future. Meanwhile, each new parking place, each picnic place, each and every increase of asphalt, each and every engine beat and consequent emission of exhaust, reduces the wildness of the moors.

OPPOSITE PAGE:
Staghounds and huntsmen, Exmoor. The hunt
continues but is ever more controversial.

Some Parks are contemplating traffic management schemes, perhaps through charging for use of the roads or restricting use of certain roads at certain times. Some are laying on extra public transport, with summer weekend buses, morning and evening, to good spots for beginning and ending walks. In this way, they hope, the problem can be contained without abridging anybody's freedom. But, truly, these are small and local answers to a large dilemma; what is needed is fresh thinking and good ideas put solidly into practice.

FARMERS AND LANDOWNERS, THE HUNT, THE VISITORS — ALL THESE ARE FEATURES OF THE DAILY life of the moors; and all the participants, though they may quarrel, have a shared interest in the survival of the moorlands. But there are many other players whose activities appear far less in tune with the spirit of wild places and their public enjoyment.

First are the military. It is natural that they should want to use rugged open space for training. It is also a fact that they have controlled the best of the north of Dartmoor for a century, using the highest, wildest parts of the moor for firing ranges, often with live ammunition. Most of their 33,000 acres are rented from the Duchy of Cornwall. The public are kept off on firing days by a system of notices and danger flags. Impeccable research has shown that the flags fly considerably more often than firing actually takes place. Critics also maintain that Bronze Age and other archaeological sites are at risk along with some of the finest tracts of peatland. What is also impaired, and most grievously so, is the spirit of the moor as we experience it.

In Northumberland, the Ministry of Defence owns 50,000 acres, almost a quarter of the National Park, and the public is permanently banned from much of this. Recently, as the Cold War ended, troop withdrawals from Germany brought an intensification of military use, and a requirement to deploy huge self-propelling guns and multiple-launch rocket systems, training over a range of 18 kilometres. Quite apart from any shelling, this kind of operation involves upgrading roads and providing facilities for vehicle parking, washing down and so forth — another asphalt onslaught on the wilderness.

It would take a fool to deny the necessity of military training. But protesters and even

OPPOSITE PAGE:
A traveller stops for the "season" to fish the valuable baby eels, or elvers, that swarm up the River Parrett in the Somerset Levels, all the way from the Sargasso Sea.

official reports assert that this use of National Park land, especially live firing, is discordant, incongruous and inconsistent with the purposes of the Parks, though in justice it must also be recorded that there are some benefits to conservation and wildlife in keeping the public off. From time to time the military make soothing noises in response to the objections. In practice, their grip on the land appears unshakeable and they have traditionally resisted pressure for any overall examination of training needs. Meanwhile, military warplanes skim over the hills at much lower altitudes than are permitted in many other countries, laying a trail of thunder on the land.

After the military there comes the problem of the conifers, dark stains of inappropriate forest deposited on many of our finest moorlands. These have come in since the 1920s, courtesy of the publicly owned Forestry Commission, as part of a programme to make Britain self-sufficient in timber. Not too surprisingly, things didn't work out quite like that, and the uplands were left with a legacy of over-rigid afforestation.

Public protest finally forced the Forestry Commission to plant more variously and more sympathetically to the landscape. Considerable efforts have also been made in recent decades to open up the forests, with paths and forestry roads, picnic areas and nature trails.

But just as this new approach was beginning to have an effect, the Forestry Commission itself was forced to reorganise, becoming part "Forest Enterprise", part "Forest Authority", and at the same time a target for partial privatisation. Wherever former Forestry Commission land has been sold into private ownership, as has happened at a brisk pace since the 1980s, there has been a strong tendency for the public to be excluded. "No right of way", say the signs on forest tracks that were formerly open. Nor have the new owners the same obligation to plant with an eye to public pleasure. This issue will cause many future rows.

Moorland quarrying, an occupation well-established over the centuries, has also become a particular worry because the scale of operations is so much larger now than it has been in the past. Bodmin and Dartmoor have extremely large china clay quarries; the Peak District and Yorkshire Dales are ravaged over wide areas by the extraction of limestone for aggregate. Of all National Parks in upland areas, in both England and Wales, only Exmoor has no active quarries.

From the opponents' viewpoint, the problem is that most of the quarrying takes place under planning permissions granted before the need for conservation became so urgent and so well-appreciated. Cancelling the permissions would involve compensation at a level that is unthinkable for the planning authorities. New conditions are indeed applied where possible, as a condition for the extension of licences — regulating the lorries that carry away the rock, obliging the quarry companies to landscape spoil heaps, to keep down dust and noise and so on. But really, looking at it in the round, it has to be admitted that quarrying is here to stay, in the National Parks as much as in other moorland areas.

The question is how far it can be confined, perhaps by taking a more rational overview of the demand for minerals. Is it really necessary, for instance, to take out china clay from Dartmoor so as to put the gloss on expensive writing paper? Or to dig up the Peak District and the Yorkshire Dales to provide the material for yet more road building?

There is, then, a daunting list of threats to England's upland moors. And there are others too, from acid rain and the possibility of destructive through-roads to the disputed issue of whether or not wind farms, with their colossal but seemingly harmless electricity-generating turbines, are a good thing or another menace to the landscape.

As for the wetlands, even with all the planning mechanisms supposed to guard the public interest, the only possible response is apprehension. Fifty per cent of all our fenlands have simply disappeared since World War Two. Again the problem is the capacity of modern machinery, in this case for pumping and draining.

Down in the Somerset Levels, decades of over-enthusiastic pumping since World War Two have done great damage to the traditional aspect of the land, accelerating the process of drying it out. Strong rearguard action by naturalists, particularly those concerned with the migratory wading birds that once abounded here, has led to National Park-style management schemes and an uneasy balance over water levels between ecologists, the farmers and the pumping authorities. Even so, bird numbers continue to decline, not least the snipe, Britain's most sensitive indicator of the health of marshy country. It is hard to feel much confidence

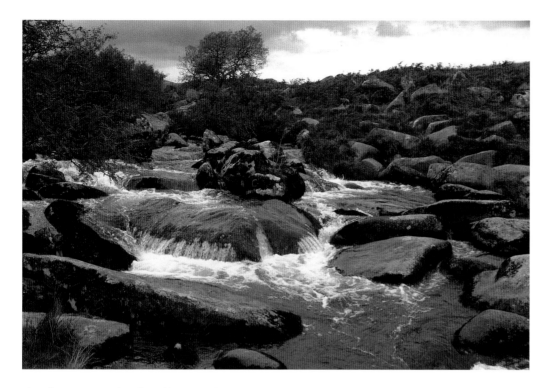

that future water levels will remain high enough to guarantee a wetland future.

Though the overall situation certainly looks grim, it may be a mistake to be too purist on these matters. History has always been made on the moors and this will certainly not stop. Yet given the depth of feeling they evoke and the opportunity they offer for an experience of something greater than ourselves, above all else for submitting our tame natures to the wild, then it would most surely be a crime to sit by passively and let the moors be chipped away or made banal. This could undoubtedly happen, is perhaps happening already. Cars are a persistent threat. There are many, many people and many organisations that do not scruple to take what they want from the moorlands regardless of the wider interest. There cannot be any question, to adapt a phrase used in another context, that the price of the wilderness is eternal vigilance.

GAZETTEER

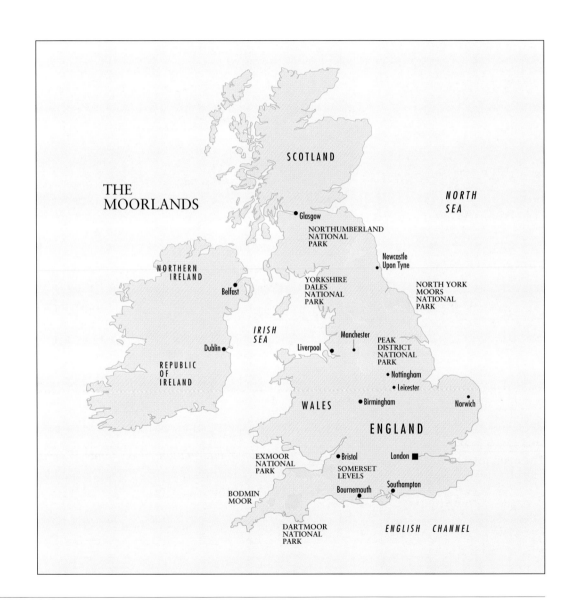

SCOTLAND

THE
MOORLANDS

*NORTH
SEA*

• Glasgow

NORTHUMBERLAND
NATIONAL
PARK

Newcastle
Upon Tyne

NORTHERN
IRELAND

YORKSHIRE
DALES
NATIONAL
PARK

NORTH YORK
MOORS
NATIONAL
PARK

Belfast

*IRISH
SEA*

Manchester

PEAK
DISTRICT
NATIONAL
PARK

Liverpool

Dublin •

REPUBLIC
OF
IRELAND

• Nottingham

• Leicester

WALES

• Birmingham

Norwich

ENGLAND

EXMOOR
NATIONAL
PARK

• Bristol

London ■

SOMERSET
LEVELS

Southampton

Bournemouth

BODMIN
MOOR

DARTMOOR
NATIONAL
PARK

ENGLISH CHANNEL

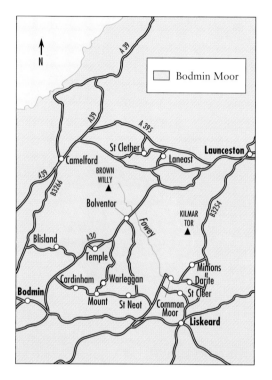

BODMIN

GETTING THERE

The main towns are Launceston to the east and Bodmin to the west of the moor, both reached by the A30, which runs right across the moor.

By express bus: Launceston, Bodmin (and Plymouth).

By rail: Bodmin Parkway, then local bus to Bodmin. Summer steam train into Bodmin.

By road: first to Exeter — M4 then M5 from London, alternatively M3 (Basingstoke) then A303 to Exeter. From north of England, M5 to Exeter. From Exeter, A30 to Launceston and Bodmin.

By air: Newquay, tel. 0637 860551. Connects directly with Heathrow, Plymouth and Ireland.

INFORMATION

There is no National Park to cover Bodmin Moor.

Local information: Bodmin Tourist Information Centre, Shire House, Mount Folly, Bodmin PL31 2DQ, tel. 0208 76616. Public transport timetables and accommodation lists available. Launceston Tourist Information Centre, tel. 0566 772321/772333 and Camelford Tourist Information Centre, tel. 0840 212954.

Regional information: West Country Tourist Board, 60 St David's Hill, Exeter, Devon EX4 4SY, tel. 0392 76351.

MAPS

For West Country generally: *OS Devon and Cornwall Touring Map*. For walkers: *OS Pathfinder* series.

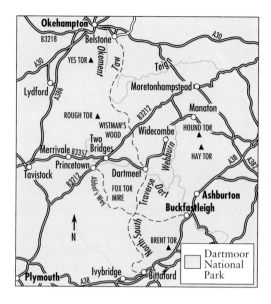

DARTMOOR

GETTING THERE

By express bus: Plymouth (south), Okehampton (north).

By rail: to Exeter (St David's), Newton Abbot, or Plymouth.

By air: Plymouth, tel. 0752 705151 (mainly London connections).

By road: to Exeter, M4 then M5 from London, alternatively M3 (Basingstoke) then A303 to Exeter. From north of England, M5 to Exeter. From Exeter, A30 for northern approach to moor, A38 for southern, B3212 crosses the moor.

INFORMATION

High Moorland Visitor Centre: The Duchy Building, Tavistock Rd., Princetown, Devon PL20 6QF, tel. 0822 890414. This is both the main information point and a major interpretative centre for Dartmoor, opened by Prince Charles in 1993. At present, it is the best such centre in any of the National Parks in the English moorlands. Open daily except Christmas Day. Easter to 31 October, 1000–1700 hrs. Winter 1000–1600 hrs. Admission free, but donation requested.

Other information points at: Postbridge; Tavistock; Steps Bridge; Okehampton; Bovey Tracey; Ivybridge.

Key publication: The Dartmoor Visitor.

Park HQ: Dartmoor National Park Authority, Parke, Haytor Rd., Bovey Tracey, Devon TQ13 9JQ, tel. 0626 832093.

Regional information: West Country Tourist Board, 60 St David's Hill, Exeter, Devon EX4 4SY, tel. 0392 76351.

MAPS

For West Country generally: *OS Devon and Cornwall Touring Map.* Locally: *OS Touring Map, no. 1, Dartmoor.* For walkers: ***OS Outdoor Leisure Map, no. 28.***

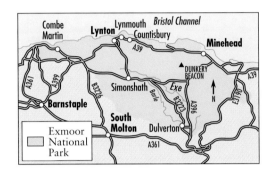

EXMOOR

GETTING THERE

By express bus: Tiverton, Barnstaple. Local bus companies operate on and round the moor.

By rail: Taunton, Tiverton or Barnstaple, then by bus. Taunton connects to Bishops Lydeard by bus, whence private (sometimes steam) West Somerset Railway to Minehead.

By road: to Bristol then south on M5 to either Bridgwater (then coastal A39) or Taunton (then A358 to join A39) or M5 exit 27 for Tiverton (then north to the moor on A396, or continue west from Tiverton on A361, finally turning north to meet the western end of the moor on A399).

By air: Plymouth, 0752 705151 (mainly London); Bristol (Lulsgate), tel. 0275 474444, good mix UK and continental airports, also New York via Dublin.

INFORMATION

National Park visitor centres: Dulverton Heritage Centre, The Guildhall Centre, Dulverton, Somerset, tel. 0398 23841. April to end October only, 1000–1700 hrs.

Other information points at: County Gate, Countisbury; Dunster; Lynmouth; Combe Martin.

Key publication: for advance reading, *Become an Exmoor Visitor* (includes accommodation). On arrival, *The Exmoor Visitor* for events, places to visit, guided walks, etc.

Park HQ: Visitor Services, Exmoor National Park Authority, Exmoor, Dulverton, Somerset TA22 9HL, tel. 0398 23665. Send postal queries here, please.

Regional information: West Country Tourist Board, 60 St David's Hill, Exeter, Devon EX4 4SY, tel. 0392 76351.

MAPS

For West Country generally: *OS Devon and Cornwall Touring Map.* For walkers: *OS Outdoor Leisure Map, no. 9, Exmoor.*

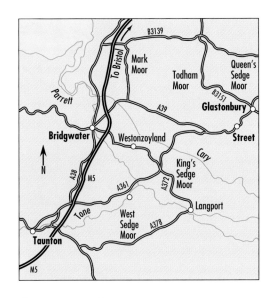

SOMERSET LEVELS

GETTING THERE

By express bus: Bridgwater, Glastonbury.

By train: Bridgwater, changing at Bristol or Taunton.

By air: Bristol (Lulsgate), tel. 0275 474444. Good mix UK and continental airports, also New York via Dublin.

By road: south from Bristol on M5, then exit 22 and east for Levels on minor roads, or exit 23, A39 for Street and Glastonbury, or exit 24, Bridgwater, then A372 for Langport, etc.

INFORMATION

There is no National Park.

Tourist information centres at: Glastonbury, 9 High St., Glastonbury BA6 9DP, tel. 0458 832954; Bridgwater, 50 High St., tel. 0278 427652.

Other information points at: Taunton, Wells.

Regional information: West Country Tourist Board, 60 St David's Hill, Exeter, Devon EX4 4SY, tel. 0392 76351.

MAPS

For general orientation: *OS Landranger, nos. 182/3.*

WHERE TO STAY

For accommodation this is the most limited moorland area, mostly B&B and some small hotels, nothing fancy.

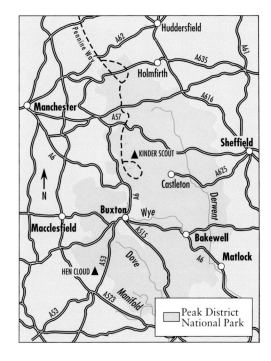

PEAK DISTRICT

GETTING THERE

This area is under greater pressure from the car than any other and the Park Authority regularly pleads for visitors to use public transport if possible. The Park information office at Bakewell (see below) will advise.

By express bus: there are services to all the main cities round the park — Manchester, Stockport, Stoke-on-Trent, Derby, Chesterfield,

Sheffield — with a National Express service into Bakewell and Buxton. Local transport in this area shows some signs of improvement. The Transpeak bus service from Nottingham to Manchester is specially useful.

By rail: Macclesfield, Stockport and Manchester on the west coast route, Chesterfield and Sheffield on the eastern side. There is a beautiful line passing through the Peaks from Manchester to Sheffield via Edale, Hope, Bamford and Hathersage. There are local lines from Manchester to Buxton; Manchester to Glossop and Hadfield; and Derby to Matlock.

By road: easy approach from north or south on the M1, exits 34, 35, 35a, 36, 37. Also, on western side, from M6, north and south. Southern approaches on A53 from Leek and A515 from Ashbourne are both rewarding. There are plentiful east-west routes through the Peaks, not so many north-south.

By air: Manchester, tel. 061-489 3000. Connects with USA and Canada, numerous British and continental airports. Also East Midlands airport (Castle Donington, Derby, tel. 0332 810621) and Birmingham International Airport, tel. 0217 675511 — New York all year, summers to Canada, good connections to northern Europe.

INFORMATION

Park Information Centre: Old Market Hall, Bridge St., Bakewell, tel. 0629 813227. Open daily in summer 0930-1750 hrs, weekends and Bank Holiday Mondays and throughout August until 1800 hrs. Winter daily 0930–1700 hrs., but closing 1300 hrs. on Thursdays. Useful and friendly.

Other information points at: Castleton; Edale; Fairholmes (Derwent Valley); Hartington Old Signal Box; Langsett Barn; Torside (Longdendale Valley).

Key publication: Peakland Post (annual newspaper); also leaflet on B&B and self-catering accommodation.

Park HQ: Peak National Park, Aldern House, Baslow Rd., Bakewell, Derbyshire DE45 1AE, tel. 0629 814321.

Regional information: East Midlands Tourist Board, Exchequergate, Lincoln LN2 1PZ, tel. 0522 529828.

MAPS

For general orientation: *OS Travelmaster 5, Northern England.* Locally: *OS Touring Map and Guide, no. 4.* For walkers: *OS Outdoor Leisure no. 1, Dark Peak* (for north), *no. 24, White Peak* (south).

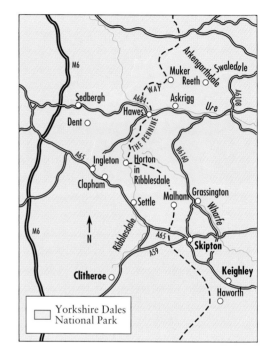

Yorkshire Dales National Park

YORKSHIRE DALES
GETTING THERE

By express bus: to Bradford and Leeds for south, Darlington for north of the area. Local bus services tend to be divided into northern and southern areas. The two are linked several times a week by the Dales Bus, a useful through service. Ask for the *Dales Connections* booklet at Park information offices (see below).

By rail: for the southern area, go to Leeds, thence Skipton, Settle and up the particularly dramatic Settle–Carlisle line, on or near moorland much of the way to Appleby (which has useful bus links). For the northern area, connections are best from the east coast route, starting from Northallerton. For the west coast route, use Oxenholme.

By road: the Yorkshire Dales lie between the two major national north-south routes — to the east the A1, to the west the M6. The Dales are easily entered at many points to east or west: M6 exits 36, 37, 38, and from A1 a wide selection of options. North-south routes within the Dales are beautiful but inconvenient for through travel.

By air: Manchester, tel. 061-489 3000. Connects with USA and Canada, numerous British and continental airports. Leeds/Bradford, tel. 0113 250 ·9696, is well placed, but less well connected.

INFORMATION

National Park visitor centres: Aysgarth, tel. 0969 663424; Clapham, tel. 05242 51419; Grassington, tel. 0756 752774; Hawes, tel. 0969 667450; Malham, tel. 0729 830363; Sedbergh, tel. 0539 620125. This is a network with no particular head office. There are local information offices at a wide range of shops, cafés, galleries and post offices.

Key publication: The Visitor, Your [annual] Guide to the Yorkshire Dales National Park.

Park HQ: Yorkshire Dales National Park, Colvend, Hebden Rd., Grassington, Skipton, North Yorks BD23 5LB, tel. 0756 752748.

Regional information: Yorkshire and Humberside Tourist Board, 312 Tadcaster Rd., York Y02 2HF, tel. 0904 707961.

MAPS

For general orientation: *OS Travelmaster 5, Northern England.* Locally: *OS Touring Map and Guide, no. 6, Yorkshire Dales,* and *OS Outdoor Leisure map, no. 2 (west), no. 10 (south), no. 30 (north and central).*

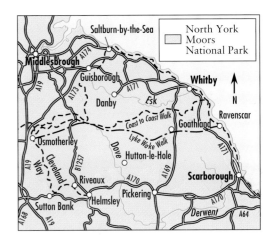

NORTH YORK MOORS

GETTING THERE

By express bus: York, Scarborough, Thirsk, Whitby. Infrequent local buses tend to skirt the edges. See the publication *Moors Connections,* available at National Park information points.

By rail: take the mainline east coast route to York, Thirsk and Darlington. Change at York for Scarborough (getting off at Molton then taking bus to Pickering for the start of the North York Moors private railway). Change at York or Darlington for Middlesbrough, whence the Esk Valley route to Whitby.

By road: From the south, A1 and A64 to York, then A169 to Pickering. From the west, from A1 to Thirsk, then A170 to Helmsley, Pickering, etc.

From the north, A19 to Middlesbrough, then A171 to Guisborough and Whitby.

By air: Teesside, tel. 0325 332811, mainly London, Holland, Scandinavia; Newcastle-upon-Tyne airport, tel. 091 286 0966, good connections UK, Scandinavia, northern Europe.

INFORMATION

The Moors Centre: Danby YO21 2NB, tel. 0287 660540, open daily March 30 to October 31, 1000–1700 hrs; November to March, weekends only, 1100–1600 hrs.

Other information points at: Sutton Bank, tel. 0845 597426; Helmsley, Market Place, tel. 0439 770173.

Information Helpline: tel. 0891 664342 (24 hrs.). Requests for information or brochures.

Key publication: North York Moors National Park Visitor.

Park HQ: North York Moors National Park, The Old Vicarage, Helmsley, York YO6 5BP, tel. 0439 770657.

Regional information: Yorkshire and Humberside Tourist Board, 312 Tadcaster Rd., York YO2 2HF, tel. 0904 707961.

MAPS

For general orientation: *OS Touring Map, no. 2, North York Moors*. For walkers: *OS Outdoor Leisure, no. 26 (west)* and *no. 27 (east)*.

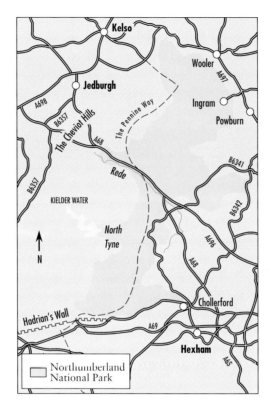

Northumberland National Park

DURHAM/NORTHUMBERLAND

GETTING THERE

By express bus: Newcastle-upon-Tyne or Carlisle, then local services.

By rail: East coast route, Darlington, Durham, Newcastle-upon-Tyne, Berwick-upon-Tweed. West coast: Carlisle. The

through-route from Newcastle to Carlisle passes through glorious scenery.

By road: on the eastern route, A1, then head west from Darlington, Durham or Newcastle for North Pennine area; Newcastle (via Otterburn), Morpeth, Alnwick, Berwick-upon-Tweed (via Wooler) for Northumberland National Park. On the western route, M6, then head east from Penrith or Carlisle.

By air: Newcastle, tel. 091 286 0966. Good connections UK, Scandinavia, northern Europe; Teesside, tel. 0325 332811, mainly London, Holland, Scandinavia; Edinburgh, tel. 031 333 1000, good connections UK, with London Heathrow shuttle; some European connections.

INFORMATION

National Park visitor centres: Ingram, near Powburn, tel. 0665 578248; Once Brewed Visitor Centre, Hadrian's Wall, tel. 0434 344396; Rothbury Visitor Centre, tel. 0669 620887.

Key publications: National Park's *What's On*. See also regional information below.

Park HQ: Northumberland National Park, Eastburn, South Park, Hexham NE46 1BS, tel. 0434 605555.

Regional information: Northumbria Tourist Board, Aykley Heads, Durham DH1 5UX, tel. 091 384 6905. Publishes annual *Northumbria Tourist Board Holiday Guide.*

MAPS

For general orientation: *OS Travelmaster, no. 4, Central Scotland and Northumberland. Travelmaster 5, Northern England* may also be useful for southern approaches, then *OS Touring Guide and Map, no. 14, Northumbria.* For walkers: *OS Landranger* series, *nos. 74, 75, 80, 81, 86* and *87.*

USEFUL ADDRESSES

British Tourist Authority (promoting tourism to Great Britain from overseas), Thames Tower, Black's Rd., Hammersmith, London W6 9EL. Offices in USA and Canada.

Council for National Parks, 246 Lavender Hill, London SW11 1LJ.

English Tourist Board, Thames Tower, Black's Rd., Hammersmith, London W6 9EL.

Ramblers Association, 1–5 Wandsworth Rd., London SW8 2XX, tel. 071 582 6878.

ACKNOWLEDGEMENTS

Special thanks must go to Prof. Mick Crawley of Imperial College, London, and to Jenny Cunningham of the Council for National Parks, for their kindness in looking over the text. Any mistakes surviving, needless to say, are the responsibility of the author — aided and abetted by the photographer!

Along the way we have received help, encouragement and advice from many people. A number feature in the book by name and they will know how much we owe to them. Helpers invisible behind the scenes, to whom we are equally grateful, include: Joan Black, Peter Bryan, Sarah Callender, David Campkin, Stroud and Jennie Cornick, Norman and Isabel Good, Richard Greenwood, Carolyn Groombridge, Jeremy and Mieke Hooker, Carolyn Jackson, Val Lowther, Richard Marvin, Peter and Patricia Miles, Peter Morgan, Michael Motley, Alan Myers, Tom and Judith Rees, Lawrence and Elsa Reid, Elaine Repath, Jocelyn Shaw, Ron Shaw, Michael and Louisa Stone, Tom and Patricia Symes, Alex Todd and Dick Wills.

And thanks from both of us to Laurie Coulter at Key Porter for patience, good humour and carefulness, and for keeping the show on the road.

INDEX

Page references in *italics* refer to photographs.

Abbot's Way, 61
Alford, Richard, 48
Alfred the Great, 44, 46
Angles, 52
Arbor Low stone circle, 36, 39, *39*
arsenic mining, 68
Arthur, King, 95, 98–99
Arthurian myth, 95, 98–100
Athelney, 44

Bainbridge, 43
Baring-Gould, Rev. Sabine, 95
barns, 82
barrows, 35, 36
beech hedges and woods, *2–3*, 83, *83*
bellpits, 68, 70
Bodmin Moor, *10, 34, 47, 74*; churches, 56;
 geology, 10; history, 46; mining, 68;
 prehistoric monuments, 35, 36
Bolton Castle, 46, 54
Bolton Priory, 58–61, 63, 67
boundary works, 39–41
Bowes, Alan "Coggie", 127
Brant Fell, 66
Brat Tor, *60*
Brent Tor, *91*, 92, 98
bridges, 61–62, *75*, 77
Britannia's Pastorals, 55
Brontë, Anne, 100, 107, 108
Brontë, Charlotte, 100, 107
Brontë, Emily, 100, 107
Brown Willy, 30
Buckfast Abbey, 61

Buckland, 48
burial cairns, 40
Burrow Mump, 89
Buxton, 43

cars, problems caused by, 128, 133
castles, 54–55
cattle, 77, 82, 104, 117
caves, 20, 92
Celts, 52, 56, 98
Chains of Exmoor, 83
chapels, *65*, 66, 67
Charles, Prince of Wales, *50*
cheeses, 117
Cheesewring Hill, *10*
Cheviot Hills, 104, 105
Chevy Chase, ballad of, 104, 105
churches, 56, 64–65
clapper bridges, 61–62
Clare, John, 77
clitter, 10
coal mining, 71, 86
Coles, John, 28
combes, 97
commons, 81, 82
conifers, 131
conservation, 119, 121, 132, 133
copper mining, 68, 69
coppicing, 39
Cornish rebellions, 46–47
cottage industries, 78, 86
Cotton, Charles, 18
Countisbury Hill, 43
crosses, 61, 88, 89
Crossing, William, 95

Dafoe, Daniel, 105
Danes, 44, 52–53
Dart, River, 14, 26
Dartmoor, *11, 12, 13, 27, 31, 32, 33, 37, 39,*
 60, 63, 67, 69, 72, 78, 91, 96, 113, 133;
 geology, 10–11, 13, 14; in literature, 104;
 mining, 48, 64, 68; in prehistoric times, 30,
 40
Dartmoor Prison, 84, *84*
deer, 14
Dent, 79
Dent, Ian, 90, *114*
Dent, Ray, 118
Dentdale, 54, 86
Dissolution of the Monasteries, 61, 62
dolmens, 35
Dove, River, 18
Dozmary Pool, 100
drainage of moors, 9, 30, 82, 132
Drake, Sir Francis, 48
drovers, 77
droveways, 59
Dunkery Beacon, *17*

enclosure, 79, 81–82
engine houses, 68, 69, 70, 71
Exmoor, *7, 15, 16, 17*, 65, 83, 93, 97, *101,*
 129; geology, 14; in literature, 105, 108;
 nineteenth-century "improvement" of, *2–3*,
 82–83

farming: medieval, 81; modern, 115,
 117–19, 121–22; monastery, 57, 58, 59;
 Norse, 53–54; prehistoric, 28, 29, 35, 39, 41
Flamank, Thomas, 46